IMAGES
of Rail

STRASBURG
RAIL ROAD

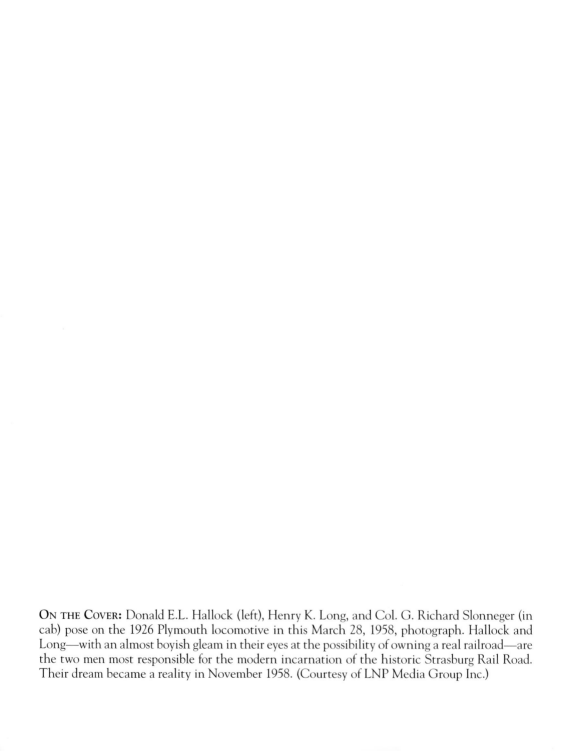

ON THE COVER: Donald E.L. Hallock (left), Henry K. Long, and Col. G. Richard Slonneger (in cab) pose on the 1926 Plymouth locomotive in this March 28, 1958, photograph. Hallock and Long—with an almost boyish gleam in their eyes at the possibility of owning a real railroad—are the two men most responsible for the modern incarnation of the historic Strasburg Rail Road. Their dream became a reality in November 1958. (Courtesy of LNP Media Group Inc.)

IMAGES
of Rail

STRASBURG
RAIL ROAD

Eric S. Conner and Steve Barrall

ARCADIA
PUBLISHING

Published by Arcadia Publishing
Charleston, South Carolina

Printed in the United States of America

Library of Congress Control Number: 2016950542

For all general information, please contact Arcadia Publishing:
Telephone 843-853-2070
Fax 843-853-0044
E-mail sales@arcadiapublishing.com
For customer service and orders:
Toll-Free 1-888-313-2665

Visit us on the Internet at www.arcadiapublishing.com

*Dedicated to America's oldest continuously operating railroad,
the Methuselah of Railroads, the Road to Paradise.*

CONTENTS

ACKNOWLEDGMENTS

Endeavoring to record a photographic history of a significant business like the Strasburg Rail Road is not an easy task. This book is unlike any other about the Strasburg Rail Road; it focuses heavily on the often-overlooked, yet important, pre-tourist (pre-1958) and transition (1958–1960) years as the railroad was saved from the scrap heap and transformed into the most visited heritage railroad in the continental United States. We are fortunate to work alongside, and in the shadow of, Strasburg Rail Road legends who graciously helped us in this process and who have had a front-row seat to it all.

The Strasburg Rail Road still endures today as generations of passengers—18 million and counting—continue to ride the famed "Road to Paradise" at America's oldest continuously operating railroad.

We are indebted to many individuals for assistance during the writing of this unprecedented book. Thank you to Linn Moedinger for opening your father's amazing photograph collection to us and for your unequaled depth of knowledge about this railroad. We thank Jeff Bliemeister and Nick Zmijewski of the Railroad Museum of Pennsylvania for your time, energy, resources, and photograph acquisition. Thank you to Stephen and Ann Weaver, Don Ranck, and Elisa Fleming for allowing us to use some of your family's photographs in this book. Thank you to Marianne Heckles of LancasterHistory.org; Sharon Kugler, Erik Huber, and MaryGrace DeSagun of the Queens Borough Public Library; and John Bachman, Henry Miller, and Rick Musser for helping us find and identify photographs. Thank you to Philip Goldstein and David Keller for the permission to feature photographs from your personal collections of Brooklyn Eastern District Terminal No. 15. Last but certainly not least, we thank Kelly Anderson, Jen Barrall, Kurt Bell, Freda Conner, Andy Hallock, Craig Lefever, Henry Miller, Linn Moedinger, Rick and Ann Musser, Stephen Weaver, and Nick Zmijewski, who carefully fact-checked and proofread this manuscript.

A sincere thank-you to the Strasburg Rail Road Company, an organization which, because of its commitment to running a top-notch, authentic steam train, has inspired us to delve deep into the stories, personalities, and equipment of its past. All author royalties from the sale of this book will be donated to the Strasburg Rail Road Company.

Throughout the text, "SRR" is used to identify the pre-1958 Strasburg Rail Road, while "SRC" designates the post-1958 Strasburg Rail Road Company.

Unless otherwise noted, all images are courtesy of the Strasburg Rail Road Company archives.

INTRODUCTION

Strasburg—a Rockwell-esque small town in the middle of bucolic Pennsylvania Dutch Country—is home to the oldest continuously operating railroad in North America and the most visited heritage railroad in the continental United States. Chartered in June 1832, the Strasburg Rail Road began serving the community of Strasburg with both freight and passenger service in antebellum America, when covered wagons and canals were still commonplace.

Today, almost 200 years later, the railroad has an active freight department and world-renowned restoration shops while still dedicated to its mission to provide an early-20th-century steam railroading experience in a safe, clean, and friendly environment.

Lancaster County's centuries-long anachronistic Amish and Mennonite culture is juxtaposed with the county's role in developing the nation's transportation systems. The area known worldwide for its picturesque "Amish Country" also produced the Conestoga wagon, birthed the idea of the steamboat through native son Robert Fulton, and hosted some of the earliest and largest canal systems during the antebellum period. By the 1820s, Lancaster was in a position to play a leading role in the creation, development, and productivity of the nation's railroad system.

When the Philadelphia & Columbia Railroad (P&C) began construction of its 82-mile rail line from Philadelphia to Columbia, Pennsylvania, in 1831, it circumvented the town of Strasburg by nearly five miles. This meant a near deathblow to the commercial and agricultural interests that heretofore helped rank Strasburg as the most populous and richest town in Lancaster County, surpassing even the county seat, Lancaster.

In response to the political kerfuffle that followed, the Commonwealth of Pennsylvania granted a charter in the summer of 1832 to create the Strasburg Rail Road so that the businesses and citizens in Strasburg would have a direct rail connection to the P&C's mainline, thus saving their influence and profitability in the larger Lancaster community.

History records little of what happened with the Strasburg Rail Road in the 20 years after its charter. What is known, however, is that by 1835, enough shares had been sold to fund grading and construction of the roadbed. The financial panic of 1837 severely hindered the further development of the railroad and postponed the town's advancement via a direct rail connection to the mainline.

By the late 1840s, the economy had stabilized enough to spur local interest in reviving the railroad. By 1851, the Strasburg Rail Road became incorporated, and soon after, it began carrying passengers and freight to and from what is now the Pennsylvania Railroad junction in Paradise, Pennsylvania, thus fulfilling the dream that started 20 years before.

For the next 107 years, business at the Strasburg Rail Road ebbed and flowed, until 1958, when a group of local investors purchased "the Methuselah of Railroads" to not only keep it alive but to develop it for bigger and better operations.

As early as the late 1930s, Americans were tired of school consolidations, war news from Europe, and an economy that had not fully recovered from the Great Depression. They romanticized the

simpler life of yesteryear. Urban Americans looked to the agrarian culture of the famed Anabaptist sects in Lancaster County as the epitome of that desired simpler life. The 10 years after World War II (1945–1955) saw steady growth in the numbers of tourists traveling to Lancaster County to get a glimpse of the Amish or try a taste of the "seven sweets and seven sours" in a traditional Pennsylvania Dutch meal. The birth pains of local tourism came to a head in 1955, when local business leader Adolph Neuber opened the area's first Amish tourist attraction during the Fourth of July weekend. With that move, the doors to the county were open, and Lancaster County tourism was officially born.

Before 1955, annual visitation to Lancaster County hovered around 25,000 people, but by 1956, nearly two million people traveled to tour Lancaster's environs. Within the decade (1955–1965), a multitude of attractions—all touting their connection with the Amish in some shape or form—sprang up as a result of the newfound interest in Lancaster County.

It is within this tourism climate that the modern incarnation of the Strasburg Rail Road was born. Arguably, the juxtaposition between the Amish culture and the classic American steam locomotive was a catalyst behind the tourist railroad's almost instantaneous boom.

When the well-connected but modest group of local railfans purchased and subsequently revived passenger service at the Strasburg Rail Road, little did they know how popular their railroad would soon become. During the first year of tourist passenger operations in 1959, annual ridership was slightly less than 9,000—still impressive for a relatively obscure railroad in Amish Country. However, by 1962—just three years after reviving railroad passenger operations—when ridership surpassed 125,000, the group of 24 individuals knew they were onto something.

The Strasburg Rail Road offered something unique to the visitor. It offered fully restored steam locomotives in a world where steam motive power had been replaced with diesel-electric. It offered beautifully restored wooden railcars in a world where the wooden railcar was obsolete for commercial purposes. And it offered a 45-minute, fully narrated ride through picturesque Amish Country farmland during a time when tourists couldn't get enough of anything Amish.

Besides the passenger operations through the bucolic Dutch Country, the Strasburg Rail Road positioned itself as a leader in steam operations. From its first steam locomotive purchase in 1960 to today, Strasburg's reputation for steam restoration, repair, and refurbishment is unequaled. The shops, staff, and roster of serviceable steam locomotives are unparalleled.

Coupled with that is the car shop where 100-year-old wooden coaches are fully restored to their original beauty. Strasburg Rail Road continues to be one of the few tourist railroads dedicated to running late-19th- and early-20th-century wooden coaches for passenger service.

Over half a century later, the Strasburg Rail Road remains dedicated to steam. It still ranks as one of the region's most frequented attractions and is the most visited tourist railroad in the continental United States, with annual ridership averaging 300,000 passengers.

Images of Rail: *Strasburg Rail Road* chronicles the unlikely success of America's oldest continuously operating railroad as told through an unprecedented selection of over 200 original and unpublished black-and-white photographs focusing primarily on the railroad's history from before 1980, with special attention given to the pre-tourist (before 1958) and transition (1958–1960) years. The photographs explain how and why Strasburg's four-and-a-half-mile line survived and how it ascended to prominence as an iconic, internationally known, small-town steam railroad.

One

STRASBURG GETS
A RAILROAD

Within two years of receiving its charter on June 9, 1832, enough stock was sold to investors, most of whom lived in the Philadelphia area, to initiate grading of the roadbed. By 1835, Strasburg merchants and businessmen were appointed to the board of commissioners to oversee construction.

Unfortunately, company records before 1851 are virtually nonexistent, so one can only speculate about how active the railroad was. If any railroad activity occurred in Strasburg prior to 1840, it would have been rudimentary at best, with horses serving as the motive power.

The financial hardship that struck the nation's economy in 1837 so severely affected the investors that all activities along the Strasburg Rail Road lay dormant as people focused on rebuilding their own financial stability.

By the late 1840s, with the economic situation stabilized, Strasburg renewed its interest in connecting to the mainline, now owned by the ubiquitous Pennsylvania Railroad (PRR) conglomerate. As a result, a second successful stock sale was initiated in 1851, during which new capital was infused into the company that allowed the railroad to purchase its first steam engine, the *William Penn*, a 4-2-0-style locomotive.

The Strasburg Rail Road survived the Civil War and several financial hardships during the remainder of the 19th century. However, when trolley lines were extended to Strasburg in 1901, passenger operations suffered a severe blow, and a major source of revenue for the railroad quickly dried up.

Believing that steam was too expensive to operate based on their meager budget, the owners of the Strasburg Rail Road purchased a 1926 gasoline-powered Plymouth locomotive, thus making the Strasburg Rail Road one of the first in the United States to completely divest itself of steam motive power.

For the next 30 years, the Strasburg Rail Road operated on a shoestring budget, with its existence hanging in the balance several times. For it to survive and thrive, the railroad needed money, devotion, labor, and most importantly, passengers. It would get all of that and more under the next group of owners.

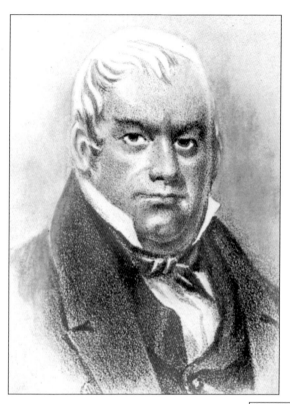

Gov. George Wolf, a staunch Jacksonian Democrat of Northampton County, Pennsylvania, served as the seventh governor of the commonwealth from 1829 to 1835. On June 9, 1832, just days before the Pennsylvania legislature's summer recess, he signed the charter creating the Strasburg Rail Road Company, under which the company continues to operate today. The Strasburg Rail Road is the oldest continuously operating railroad in the United States and operates under its original charter and original name. (Courtesy of Eric S. Conner.)

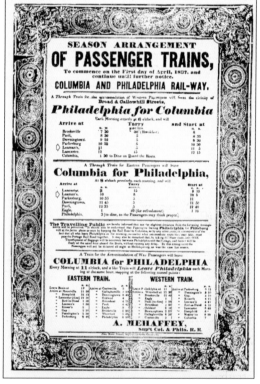

The construction of the Philadelphia & Columbia Railroad in 1831 and subsequent geographic circumvention of Strasburg was the driving force behind the creation, construction, and completion of the Strasburg Rail Road. If not for the P&C and the uproar that followed, Strasburg's short line would not have been needed. This 1837 ad for the P&C is one of the earliest items in the company archives and specifically mentions the interchange at Leaman Place.

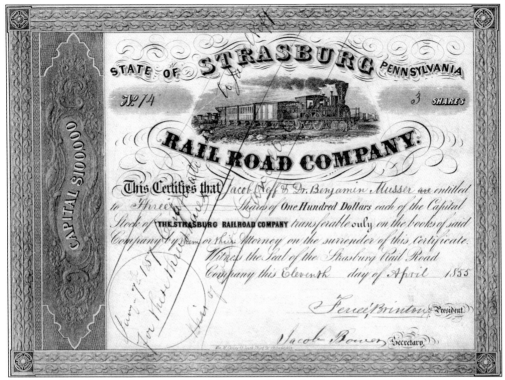

Because of the financial panics of the 1830s and 1840s, the railroad saw no significant progress; however, by 1851, interest once again turned to completing the rail connection. Also in 1851, an aggressive stock sale began to infuse new capital into the company. Shown here is one of the earliest issued stocks extant. This particular certificate, number 14, issued to Jacob Neff and Dr. Benjamin Musser on April 11, 1855, is signed by Ferree Brinton.

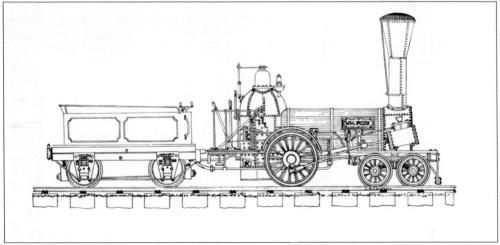

With the line finally completed and the infusion of new capital, the Strasburg Rail Road purchased its first steam locomotive, the *William Penn*, a 4-2-0 locomotive built by the William Norris Locomotive Works in 1835. It is believed to have been one of the first 50 steam locomotives built in the United States. It spent its first 16 years on the P&C before being sold to Strasburg in 1851. Strasburg sold the locomotive in 1865.

After the Strasburg Rail Road obtained its first steam locomotive, an advertising campaign began to garner business and inform the community of the new transportation to PRR's mainline. Jacob Werntz of Main Street proclaimed in an ad in the *Strasburg Bee* that he had carried the "first goods over the Strasburg Rail Road" in September 1852. Shown here is a rare advertisement for the Strasburg Rail Road from December 1852. The ad mentions "this company now having fully equipped their road . . . prepared to forward all kinds of produce . . . to and from Philadelphia and Baltimore."

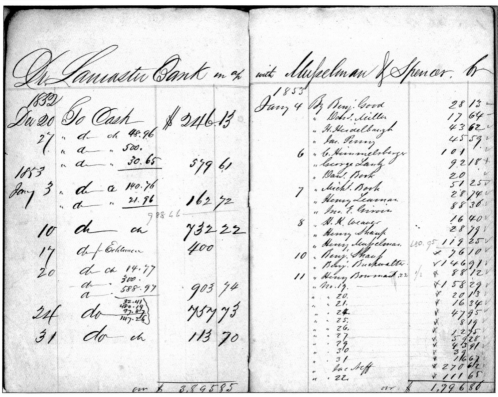

The firm of Musselman & Spencer, proprietors of the Strasburg Rail Road, had its account with the Lancaster Bank. This is the first page of the first ledger book in which the railroad's assets are recorded. The book begins in December 1852, just four months after passenger operations began, and continues through 1854. The failure and subsequent closure of the Lancaster Bank during the Panic of 1857 precipitated the railroad's financial losses in 1858 and led to a sheriff's sale in 1859.

"Strasburg Railroad, Depot Buildings, etc. for rent" reads the headline in this September 1858 ad in the *Lancaster Examiner*. After the Panic of 1857, the Lancaster Bank—the railroad's primary financial institution—collapsed, and the amount of goods carried did not cover operating expenses, so the owners tried to garner revenue through other means. The railroad never fully recovered financially and wasn't producing a return for its investors, so the owners liquidated it at a sheriff's sale in April 1859 for the sum of $13,000. The Honorable Ferree Brinton purchased the stock as an agent for himself and 22 other investors.

IMPORTANT TO BUSINESS MEN.

Strasburg Railroad, Depot Buildings, &c., for rent by public vendue.

WILL be rented on WEDNESDAY, the 20th day of OCTOBER, 1858, at 2 o'clock, P M. at the public house of Henry Bear, in the borough of Strasburg, Lancaster county, Pa., all that certain RAILROAD, running from the said borough to, and connecting with the Pennsylvania Central Railroad at Lemon Place Station, together with all the DEPOT BUILDINGS, LOCOMOTIVE ENGINES, PASSENGER AND FREIGHT CARS, and other equipments thereunto belonging. The depot buildings are situated at the east end of the borough of Strasburg, and are surrounded by one of the most fertile and highly cultivated agricultural districts in the County of Lancaster. The facility for purchasing and forwarding all kinds of Grain, Flour, Whiskey and other produce, and for the disposal of Lumber, Coal, Salt, Guano, Plaster, &c., and for the freighting of merchandize are unsurpassed. To any person or persons wishing to embark in the Forwarding Business an opportunity is now offered rarely to be met with. A further description is deemed unnecessary, as persons wishing to rent will view the premises.

Terms and conditions on the day of renting.

By order of the Board of Directors.

HENRY H. BRENEMAN,
sep 22-td 42 Secretary.

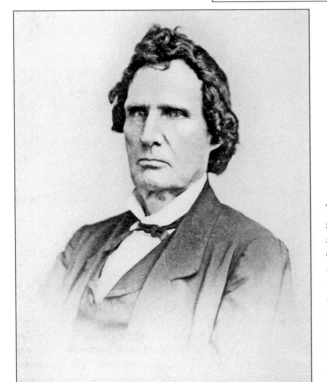

Thaddeus Stevens, the preeminent abolitionist during the antebellum and Reconstruction eras who eventually led the impeachment against Andrew Johnson in 1868, was not only a champion of public education but also an avid proponent of railroads as early as the 1830s. Stevens, the ardent railfan, was one of the 23 investors who purchased stock in conjunction with the 1859 sheriff's sale. (Courtesy of Eric S. Conner.)

Know all men by these presents, That whereas "Herr & Co." to wit: John F. Herr, Cyrus N. Herr and Amaziah M. Herr, have purchased by articles of agreement of July 29th 1868, of William Spencer, of the Borough of Strasburg, thirteen 144/100 acres of land, situate in the township of Strasburg, ~lying~ adjoining the Strasburg Rail-Road Depot property, for the sum of (four thousand one hundred and seventy dollars ($4170.—) and have sold part of the aforesaid tract of land to different persons, and purpose making further sales to purchasers — The proceeds to be used for the benefit of said Company.

The said Company hereby agrees that the title of conveyance shall be vested in Amaziah M. Herr, one of the firm, that he may convey to the purchasers, until the Company is satisfied with the sales, he shall then convey the remainder of the tract to the Company to be held in common. The said Amaziah M. Herr, shall have no further interest in said tract of land, than either of the other members of said of the said Company.

Witness our hands and seals this twenty-fifth day of March, one thousand eight hundred and sixty-nine.

Witness present
P. Spencer

John F. Herr
Cyrus N. Herr
A. M. Herr

The Herr brothers—Cyrus, John, and Amaziah—purchased controlling interest in the Strasburg Rail Road in 1866 and promptly built a flour mill, planing mill, and machine shop all under the name of Herr & Company. The Herrs owned a controlling interest in the railroad until 1871. This nondescript contract among the brothers from 1869 mentions their purchase of 13 acres of land surrounding the railroad terminal for $4,170 in July 1868.

Ex-PRR D5 4-4-0 No. 929, built in 1873, traverses Strasburg's coal trestle along the Gap Road (Route 741) in this c. 1895 photograph. Strasburg Rail Road purchased No. 929 from the PRR in 1892 and renumbered it as the first known SRR No. 1. Over the years, Strasburg would have four locomotives numbered No. 1. PRR No. 929 ran at Strasburg until about 1906, when it was replaced with Strasburg's second locomotive No. 1, ex-PRR 4-4-0 No. 937. (Ben Kline Collection, Railroad Museum of Pennsylvania, PHMC.)

One of the earliest photographs of buildings associated with the Strasburg Rail Road is this c. 1895 view of the lumber and feed mill on Georgetown Road. An unidentified steam locomotive (possibly the ex-PRR D5 4-4-0 No. 929) sits in the engine house at center, its headlight barely visible. The shorter two-story building on the left was the former Herr & Brackbill Company, manufacturer of various agricultural equipment. The building was later used as the milk depot.

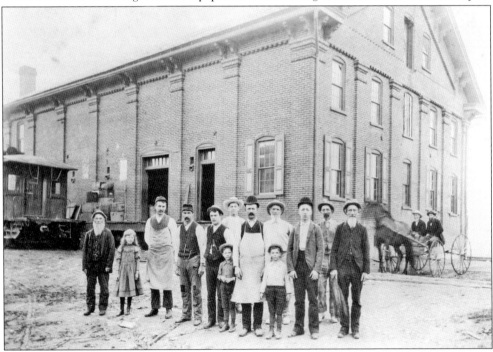

Tobacco, lumber, and coal workers from the Musselman Mill pose for a photograph in front of the building (the future Homsher Mill) in this rare view from about 1900. Note the unidentified railroad car sitting at the platform, then serving as the Strasburg Rail Road passenger and freight depot. The mill building was the hub for a tobacco, lumber, coal, and feed operation for much of the 20th century. (Courtesy of LancasterHistory.org.)

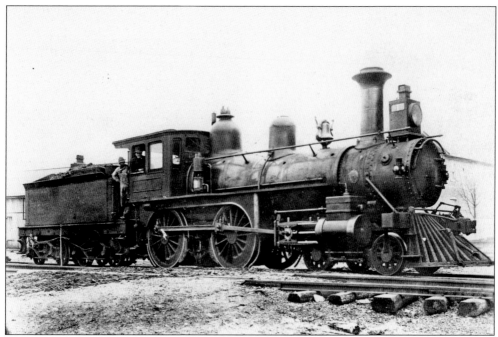

No. 929's replacement was PRR No. 937, later renumbered as the second SRR No. 1. This 4-4-0 Baldwin locomotive was built in April 1876 for the Philadelphia Centennial Exposition at a cost of $9,000. The locomotive was sold to the Strasburg Rail Road in May 1906 after 30 years with the PRR. Strasburg used this engine until the end of 1924, when it was retired from Interstate Commerce Commission (ICC) service. George Trout (in cab) is the engineer, with Gus Westfall as fireman. The locomotive is sitting at Leaman Place Junction on the station team track.

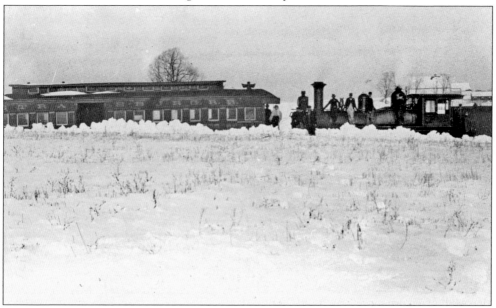

PRR No. 5203, a c. 1860s combination baggage and passenger coach with a distinctive monitor roof—the earliest type of passenger car roofline—is coupled to ex-PRR D3 No. 937 (SRR No. 1) in this undated photograph of a Lancaster County snowstorm.

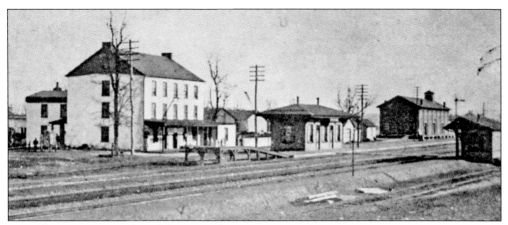

The village of Leaman Place did not exist before the railroads. Once the Philadelphia & Columbia passed through, Henry Leaman—for whom the future junction was named—built a house and hotel, seen here, in 1835. Soon thereafter, a train station was built, which precipitated the creation of the small town surrounding the railroad station. (Courtesy of LancasterHistory.org)

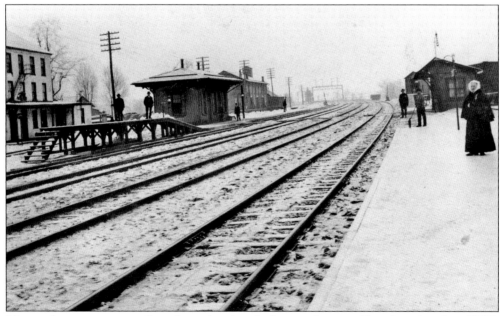

Men work to remove snow from the pedestrian platforms at Leaman Place Junction along PRR's mainline in this c. 1900 photograph. A boxcar sits on the connecting line of the Strasburg Rail Road behind the southern (right) platform. In February 1861, president elect Abraham Lincoln briefly addressed a jubilant crowd at this junction while on his way to Washington.

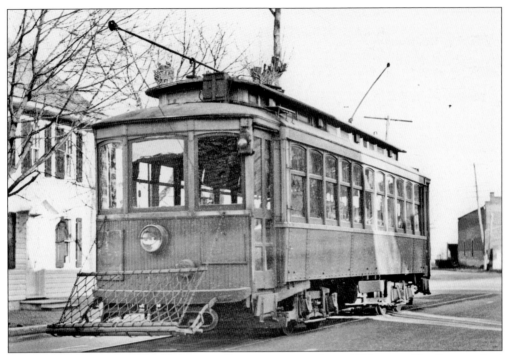

Although Lancaster City had electric trolley service as early as 1890, no trolley line reached Strasburg before 1901. Until then, Strasburg residents relied solely on the railroad to connect them to Lancaster. But after the trolley came to town, travel time and cost to Lancaster was reduced by half, thus thrusting a blow to one of the railroad's consistent revenue streams. In essence, trolley service in Strasburg began the demise of passenger service on the short-line railroad. One of Strasburg's early trolleys is seen here.

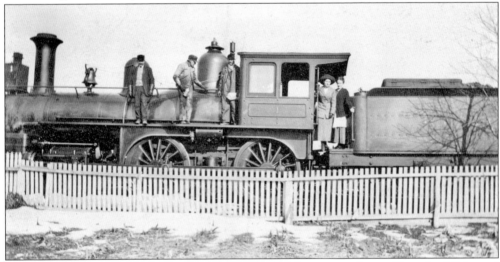

Gus Westfall (left of the cab), Billy Westfall (far left), and their cousin George Trout (middle) stand on the running board of the former Pennsylvania Railroad class D-3 "cabbage head" locomotive No. 937 in this c. 1912 photograph. Gus's wife, Mollie (right of the cab), and Billy's wife both stand in the gangway. When he was not running trains to and from Paradise, Gus Westfall played baseball for the local Strasburg team.

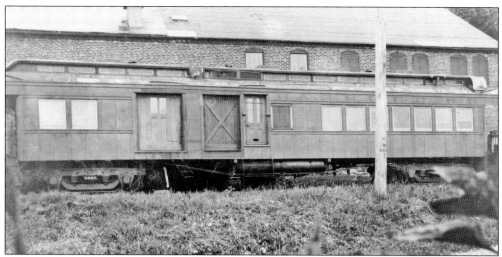

An ex-PRR combination baggage and passenger coach, No. 5203, is seen on the north side of the milk depot in this c. 1915–1920 photograph. Notice the extra door in the baggage compartment, which was modified to better load and unload milk bottles and cans. Strasburg Rail Road used half the car to haul milk to the mainline from local farms for the Supplee Wills–Jones Dairy in Philadelphia. After passenger operations all but ceased in the first quarter of the 20th century, the car was used almost entirely for hauling milk and other freight. Later, it was cut down to a flatcar and retired from ICC service in 1929.

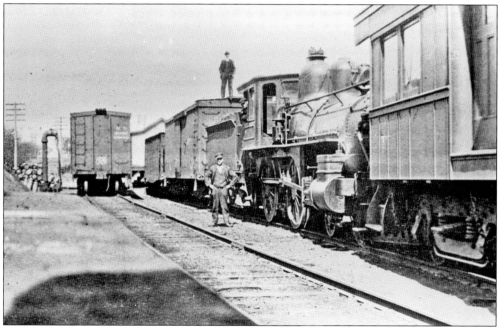

In this c. 1918 photograph, the crew of SRR No. 1 (PRR No. 937) poses at Leaman Place after some switching and before heading back to Strasburg with their daily mixed train. SRR No. 1 is coupled to two wooden boxcars and the railroad's sole coach car. George Trout is in the cab, while his cousin Gus Westfall poses on the ground. Billy Westfall is standing on top of the boxcar. The Leaman Place Station is in the background. (Ben Kline Collection, Railroad Museum of Pennsylvania, PHMC.)

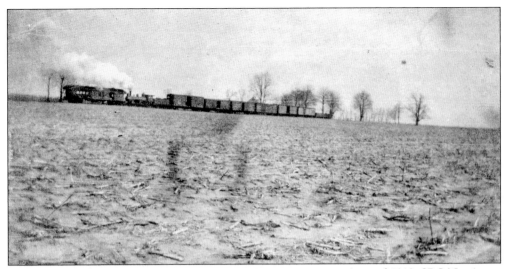

Around 1918, SRC No. 1 with its seven-car consist passes through the Ranck family farm (now known as Verdant View Farm), as trains have done ever since the *William Penn* ran at Strasburg in the 1850s. The railroad's modified PRR combination baggage and passenger car is coupled to the locomotive's front. (Courtesy of the Ranck family.)

State senator John Galen Homsher purchased the Strasburg Rail Road from Frank Musselman in 1918. Homsher, a political powerhouse during the political boss era, was in his eighth term as senator when he died of a heart attack in September 1938. Ownership of the railroad transferred to his two sons, John E. and Fred L. The latter also succeeded his father in the Pennsylvania Senate. (Courtesy of Henry Miller.)

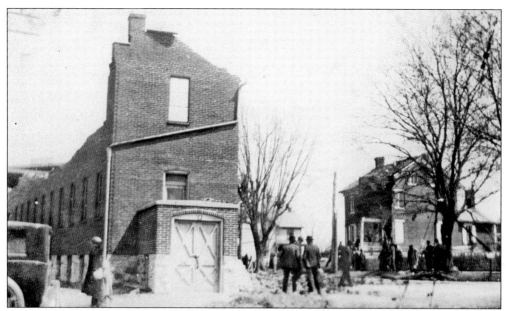

A severe windstorm that produced a tornado passed through Lancaster County on April 24, 1926. The storm affected central and southern Lancaster County, including the Homsher tobacco warehouse at the western terminal of the train depot. This photograph, taken the next day, shows the tobacco warehouse missing its upper floor as a result of the storm. (Courtesy of the Ranck family.)

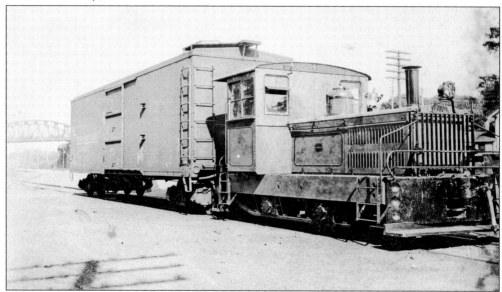

Plymouth Locomotive Works, of Plymouth, Ohio, was one of the most prolific builders of small gasoline- and diesel-powered industrial locomotives in the first half of the 20th century. In 1926, after determining that steam was too expensive to run at the Strasburg Rail Road due to the lack of passengers and dwindling freight revenue, the Homshers purchased a new 20-ton Plymouth locomotive as their sole motive power in 1926. Seen here is Plymouth No. 1 shortly after its purchase with a PRR boxcar at Leaman Place Junction. The 1923 steel bridge carrying US Route 30 over the PRR mainline is in the background.

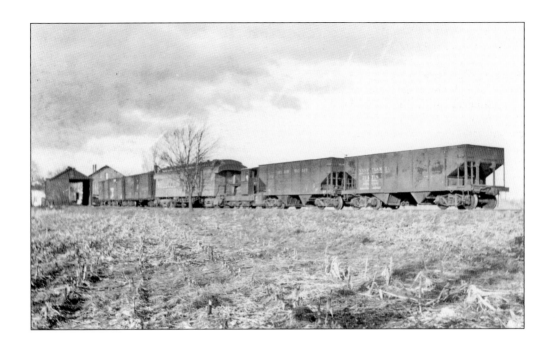

Plymouth No. 1, in the middle of the consist above, brings in three unidentified boxcars, PRR passenger car No. 5203, a Lehigh Valley Railroad hopper, and PRR hopper No. 214718 as it approaches the freight terminal at the Homsher Mill just after passing through the Route 741 crossing in the first of these two late 1920s photographs. The photograph below shows Tom Bair (left) and Earl Fenninger posing on Plymouth No. 1 just after its return to the depot.

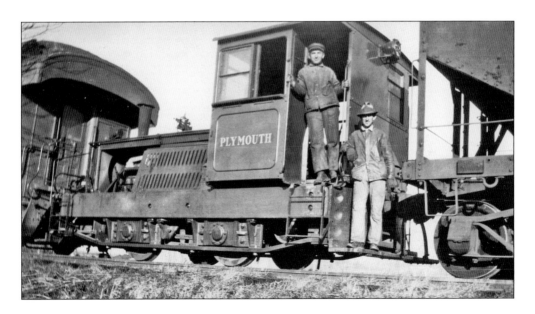

Elsie Ranck Newswanger (1905–1978), daughter of Enos Ranck, through whose family farm the Strasburg Rail Road passes, stands on the end platform of the railroad's sole passenger car in this mid-to-late-1920s photograph. Even though the car was retired from passenger service in 1929, it was often used as a caboose of sorts on freight runs. It is believed that the car remained on the property through the mid-1950s. (Courtesy of Stephen and Ann Weaver.)

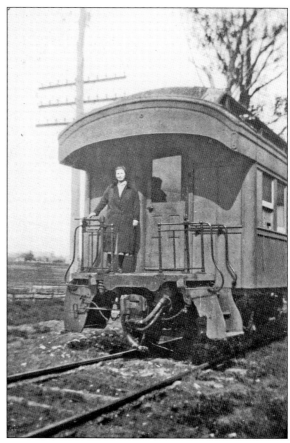

In 1928, the Pennsylvania Department of Highways finally upgraded Route 741 from a dirt and gravel road to a modern paved road. As equipment rolled in for the construction project, 23-year-old Elsie Ranck took the opportunity to pose on a brand new c. 1925 Galion Standard Premier road grader as it sits beside the tracks at the railroad terminal just a mile from her home. (Courtesy of Stephen and Ann Weaver.)

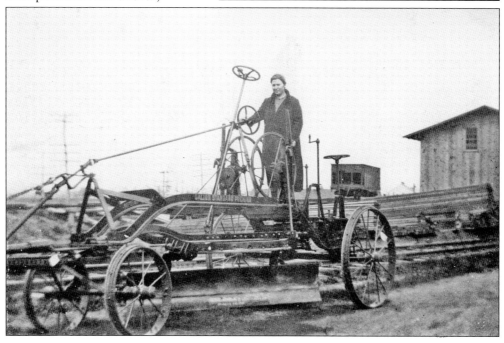

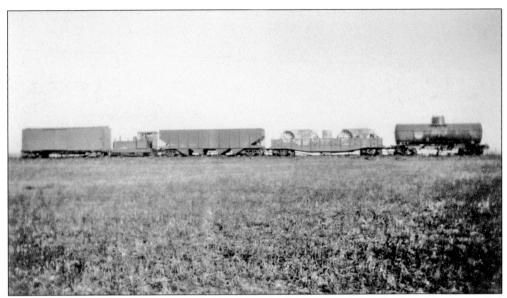

On one of its daily freight runs, Plymouth No. 1 picked up two 1920s road rollers, which traveled to Strasburg via a PRR flatcar. This photograph, taken in the summer of 1928, shows the train running through the Enos Ranck farm adjacent to the soon-to-be-paved Route 741. The road rollers were used in the paving project. (Courtesy of Stephen and Ann Weaver.)

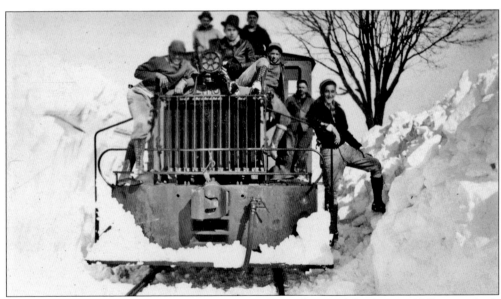

Lancaster County winters are harsh, and the fields and cuts of the Pequea Valley in which the Strasburg Rail Road runs are susceptible to drifting snow. Regardless of weather, railroad operations must continue. This mid-to-late-1930s photograph shows teenagers from Strasburg posing on Plymouth No. 1 after they helped to clear the snow so that the locomotive could navigate the rails.

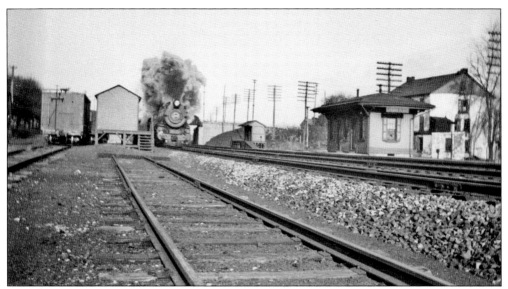

An unidentified PRR locomotive rushes through Leaman Place Junction on the Pennsylvania mainline in this 1930 photograph. A boxcar (possibly ex-PRR No. 96451, acquired in 1929) sits on Strasburg's connecting line behind the eastbound passenger shelter. The westbound passenger depot is across the mainline. (General Negative Collection, Railroad Museum of Pennsylvania, PHMC.)

The unadulterated farmland surrounding the west side of Cherry Hill is seen in this c. 1940 photograph. This land originally belonged to Cornelius Ferree, a great-grandson of Marie Ferree, the matriarch of the 1712 French Huguenot settlement in Lancaster County. The Cornelius Ferree house (not shown), then owned by Melvin and Polly Stoltzfus, still stands on the property.

NOTICE

By Executive Order dated the 27th day of December, 1943, the President of the United States acting through the Secretary of War, has taken possession and control of the transportation facilities of this Company effective as of Seven o'clock PM December 27th 1943. This action was taken to avoid a threatened interruption of vital transportation service. The continued operation of the facilities thereby taken is essential to the successful prosecution of the war.

HENRY L. STIMSON
Secretary of War

During the latter half of World War II, the US government took supervisory control of all the railroads to "avoid a threatened interruption of vital transportation services." The government takeover of the railroads, which included even the unremarkable Strasburg Rail Road, took effect on December 27, 1943, as mentioned in this, the original telegram sent to the owners of the Strasburg Rail Road, Fred and John Homsher. As a result, 1st Lt. Robert L. Mulgannon arrived at Strasburg in January 1944 to supervise operations and the railroad's only two employees—Tom Bair and Ray Althouse. The lack of activity at this small railroad resulted in Mulgannon's assignment lasting only four days.

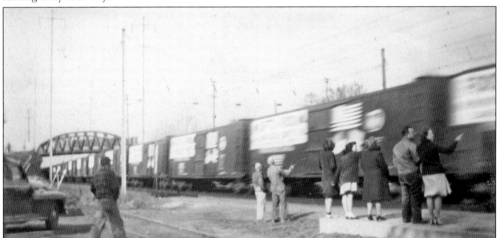

In conjunction with the Marshall Plan, the idea of the "Friendship Train" was proposed, which was designed to collect food for the people of war-torn France and Italy. The train began in Los Angeles on November 7, 1947, and traveled to New York over the next 11 days. Ultimately, the train collected 700 cars' worth of food bound for Europe. This photograph shows the Friendship Train passing through Leaman Place Junction on November 17, 1947, on the final leg of its journey. (Courtesy of the Ranck family.)

STRASBURG RAILROAD
COAL, LUMBER, GRAIN, FEED
FRED. L. & JOHN E. HOMSHER.

Pictured here is one of the hand-painted, wooden Strasburg Rail Road signs from the Fred and John Homsher era (1938–1955). This particular sign, advertising the company's key commodities, adorned the south exterior wall of the Homsher Mill just above the building's loading platform until the mill was sold to I.B. Graybill in the spring of 1959.

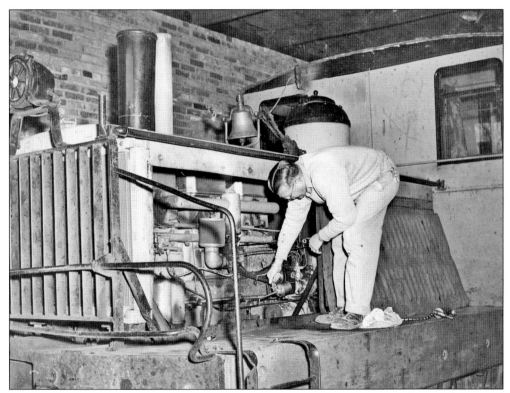

A rarely seen view from inside the diminutive engine house, taken around 1953, shows Earl Fenninger on the Plymouth's gangway while he lubricates the engine to prepare for an impending run to Paradise.

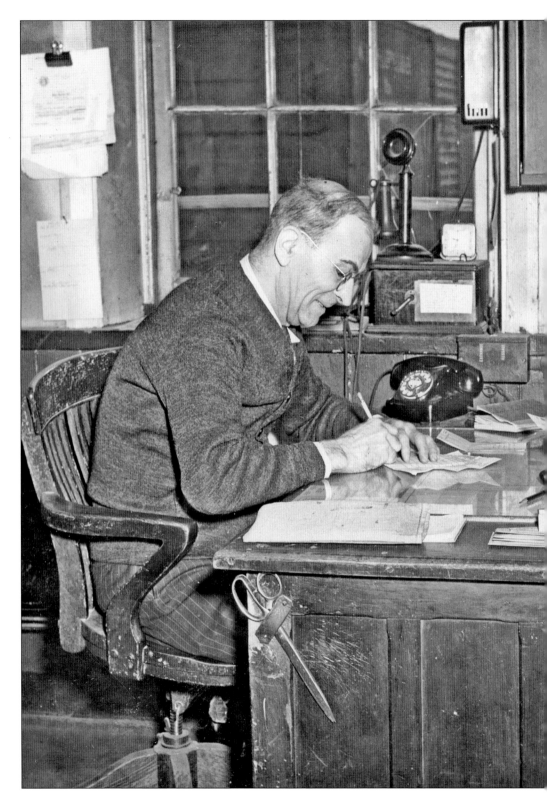

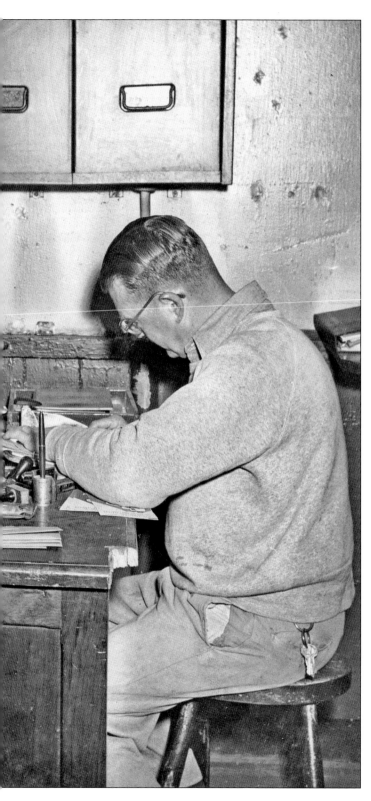

PRR agent Ralph E. Helm (left) and Strasburg's Earl Fenninger are seen working on company paperwork in this 1953 photograph taken from inside the Strasburg Rail Road's freight house at Leaman Place Junction. Note the telephone from Automated Electric, a major supplier of radio communication equipment, and the clock that reads 9:35 a.m. Fenninger worked for the Homsher brothers—Fred and John E.—who took over railroad operations after their father, John G. Homsher, died in 1938.

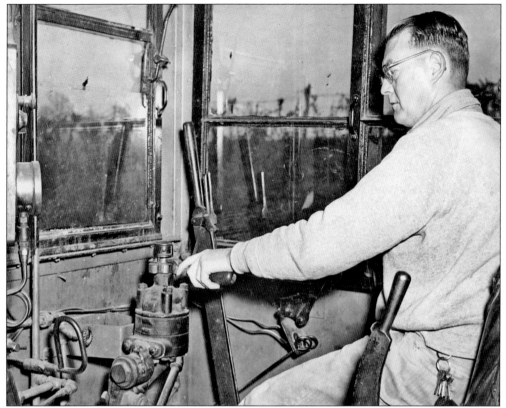

Earl Fenninger is behind the controls of the Plymouth locomotive in this unusual cab interior photograph from around 1953. Upon the death of his brother, Fred, in 1950, John E. Homsher became the majority owner of the Strasburg Rail Road. John E. Homsher died unexpectedly five years later, at which time ownership transferred to his heir and nephew, John Bryson "Jeff" Homsher, who owned it until his premature death in 1957.

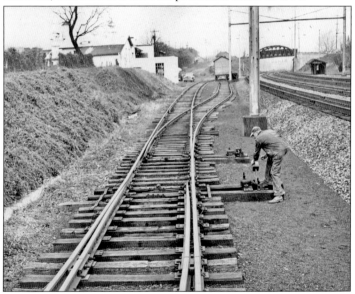

Part-time brakeman and one half of the employee roster of the Strasburg Rail Road at the time, Raymond H. Althouse throws the interlocking lead switch to prepare for a freight move in this c. 1952 photograph taken at Leaman Place Junction. Note the c. 1923 milk shed and loading ramp are still standing.

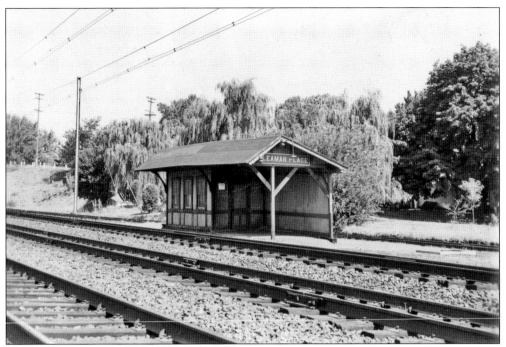

The dilapidated and well-worn PRR westbound station platform at Leaman Place is seen in this July 17, 1954, photograph by Earl Weber of Ashland, Kentucky. This view is looking west; the Denlinger Mill lead track is just behind the station. Shortly after this photograph was taken, the station building was removed.

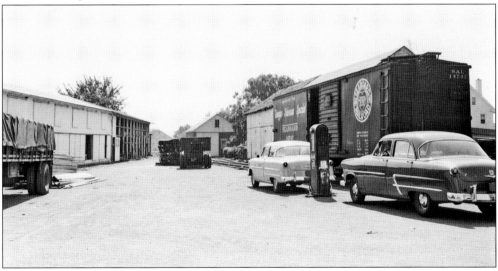

Two 1954 Fords—a four-door sedan and a Victoria—sit alongside an *Orange Blossom Special* Seaboard Railroad boxcar in this summer 1954 view of the Strasburg Rail Road and Homsher Mill freight yard. Both cars sport bumper stickers advertising the Strasburg Firemen's Festival on Saturday, August 7, of that year. Approximately two months after this photograph was taken, Hurricane Hazel washed out portions of the main track and physically crippled operations; the Homshers never fully recovered. (General Photographs Collection, Railroad Museum of Pennsylvania, PHMC.)

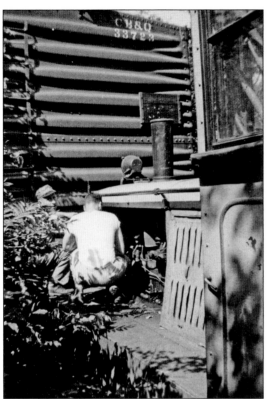

Tom Bair (left), engineer, and an unidentified man are repairing the fan/air compressor belt on Plymouth No. 1 while trying to pass through Rohrer's Cut on their way to Leaman Place Junction in September 1957. The condition of the equipment and the roadway left a lot to be desired.

James Hallock stands on the rear of Plymouth No. 1 at the Leaman Place Junction in September 1957. The gasoline locomotive, painted in a drab gray livery, is delivering a Chicago, Burlington & Quincy (CB&Q) boxcar to the interchange. Notice a PRR freight train on the mainline.

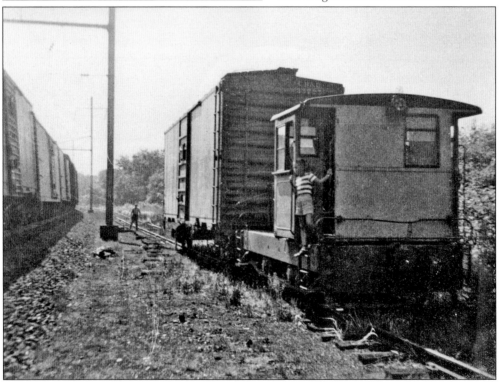

Two

SAVING STRASBURG

By 1954, the Strasburg Rail Road had weathered four wars, three depressions, and one government takeover. Through it all, the railroad continued to operate on its four-and-a-half-mile run to the mainline, despite the rapidly declining condition of its weed-infested rails. Through much of the early 1950s, railroad operations were sporadic at best. Hauling roughly 200 carloads of freight annually and with annual gross revenue of less than $3,000, the Strasburg Rail Road was the smallest and possibly the poorest railroad in the nation. The lack of frequent business, inadequate funds, and insufficient manpower were three reasons why the physical condition of the railroad was so dilapidated.

Then Hurricane Hazel hit Lancaster County in October 1954 and washed out the tracks in several places, leaving the rails impassable. Hazel crippled railroad operations at Strasburg.

After the hurricane, John Bryson "Jeff" Homsher, grandson of state senator John G. Homsher who purchased the railroad in 1918, managed railroad operations almost singlehandedly between 1955 and 1957. Despite the destruction left by Hurricane Hazel, the operations continued, but tractor trailers served as the motive power to Paradise while washed-out portions of the rails were rebuilt. However, when Jeff Homsher died in November 1957, the future of the railroad was uncertain. It appeared that Strasburg's little railroad was headed to the scrap heap.

In late March 1958, a week after a blizzard dumped more than a foot of snow, Henry K. Long, Donald E.L. Hallock, and several fellow railroad enthusiasts met to discuss the purchase of the Strasburg Rail Road from the Homsher estate. They were determined to keep what was described as "the Methuselah of Railroads" alive. They were determined to save Strasburg.

After the better part of a year of dedicating their time and effort to clearing waist-high weeds, repairing rails, and relaying ties, their dream became a reality on November 1, 1958, when the sale of the railroad was completed. A new day was dawning on the Strasburg Rail Road.

The first run under new ownership occurred on November 8, 1958, when the diminutive 20-ton Plymouth No. 1 gasoline locomotive, with Huber Leath as engineer and Henry Long as conductor, made its way eastward on the four-and-a-half-mile stretch to Leaman Place to pick up a load of railroad supplies.

By 1960, excursion trips were so popular that passenger operations needed more substantial motive power. The directors looked for a solution. Their solution was steam.

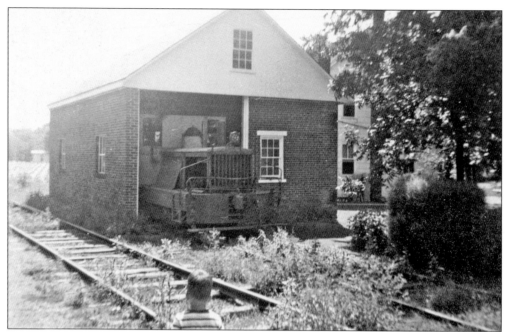

When this photograph was taken in September 1957, the Strasburg Rail Road was about to start the transition from a nearly dormant railroad to a popular tourist attraction. A young Andy Hallock looks at SRR No. 1 as it exits the engine house. Little did he know that one year later, his father would be part-owner of that locomotive.

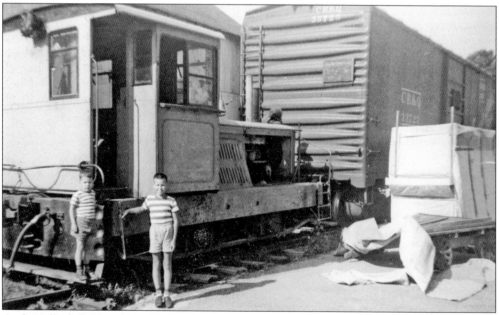

Andy Hallock (left) and his older brother Jim stand beside Plymouth No. 1 before embarking on a run to deliver CB&Q boxcar No. 33727 to Paradise. The Hallock brothers, sons of future SRC vice president Donald E.L. Hallock, grew up at the Strasburg Rail Road; the Hallock family has been involved with the railroad ever since the rebirth of the company in 1958. Andy Hallock joined the board of directors in December 2000, shortly before his father's retirement from the board.

The lack of sufficient funds due to sporadic freight traffic left the railroad with little to no money for maintenance of way. By the time the railroad was offered for sale in 1958, waist-high weeds and other cover crops had overgrown the tracks; ties were rotted, and the tracks had even been buried in places. It took the better part of a year to bring the four-and-a-half-mile stretch of track up to operating standards—all at the potential new owners' risk.

The condition of the tracks can be seen in this September 1957 photograph taken from the Plymouth's cab window. It is believed this photograph was taken near Rohrer's farm, just east of Esbenshade Crossing. Tracks can be seen hidden in the brush, grass, and other assorted cover crops that are indicative of Lancaster's fertile soil. The tracks were there; it was just a matter of uncovering them.

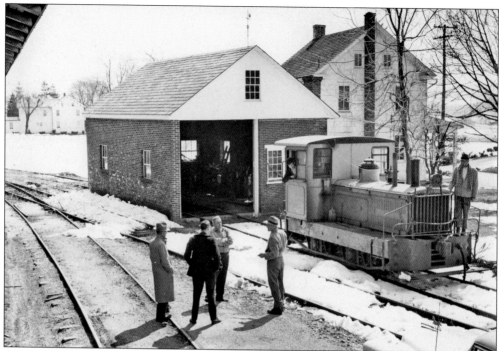

On the morning of March 29, 1958, just before the organizational meeting at Donald E.L. Hallock's home at which the modern business model for Strasburg's operation was pitched before 12 potential investors, several of the men conducted a Strasburg Rail Road equipment inspection. These two photographs taken during the inspection visit show the 20-ton, gasoline-powered 1926 Plymouth No. 1 in its rundown, drab gray livery in front of the diminutive engine house. The photograph above, by Fred Schneider III, shows Henry K. Long standing on the locomotive while G. Richard Slonneger sits in the cab. Isaac Hershey (left), Les Myers (middle, facing), and Don Hallock (right) converse between the well-worn tracks with another individual as yet unidentified. Long's 1954 Cadillac is in the foreground. The photograph below, published by the *Lancaster New Era*, shows Hallock (left), Long, and Slonneger (in cab) posing on their future locomotive. (Below, courtesy of LNP Media Group Inc.)

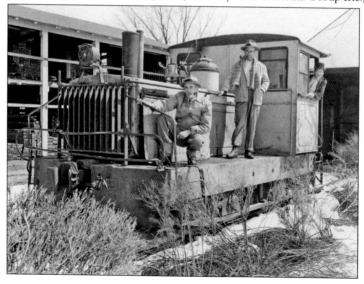

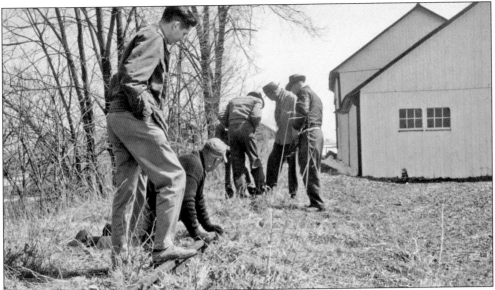

Huber Leath (far right) and Henry Long (second from right), among others, stand behind the current location of the Choo Choo Barn in March 1958 as they evaluate the track conditions and discuss the needed work to bring the track up to acceptable operating conditions. The condition of the track was such that a lining bar was essential on inspection trips to Paradise Junction. The track car often needed to be prodded when it ran into buried tracks along the way. (Huber Leath Collection, Railroad Museum of Pennsylvania, PHMC.)

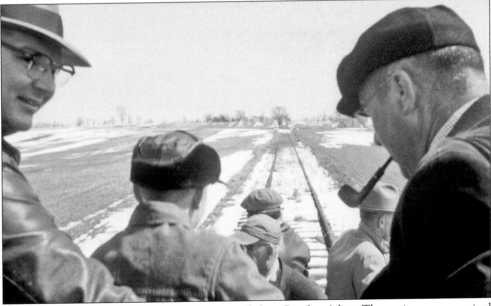

Throughout 1958, several inspection trips occurred along Strasburg's line. These trips were organized essentially as goodwill trips to garner local support for the pending purchase and rejuvenation of the railroad. J. Huber Leath (left) and "Check" Caldwell (right), two of Strasburg's first vice presidents, lead a group of unidentified local railfans, presumably from the local chapter of the National Railroad Historical Society (NRHS), through Amish farms on an inspection trip to historic Leaman Place Junction. (Huber Leath Collection, Railroad Museum of Pennsylvania, PHMC.)

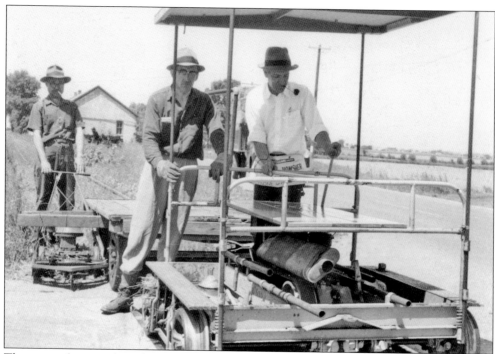

These two photographs, taken on Saturday, June 7, 1958, show, from left to right, Henry Long, Dick Slonneger, and Don Hallock (sporting an F.L. Homsher cloth tool belt) using their track car and a push car for one of the many weed-cutting ventures down the rails. The push car was retrofitted with a power mower attachment to mow the grass and weeds in the right-of-way. The track conditions were so bad that parts of the track were nearly impassable. After making it across Route 741, the mower needed to be unclogged from the high grass. The photograph below shows Hallock (left) and Slonneger working on the mower in the hot June sun.

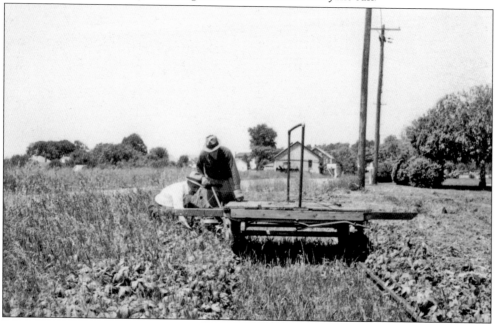

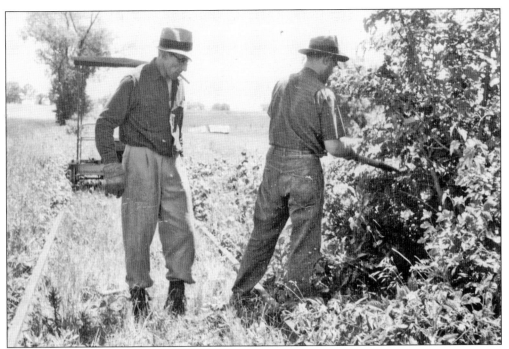

Henry Long cuts back brush from the railroad's right-of-way as part of the workday on June 7, 1958. The four-cylinder Northwestern track car is waiting just a few feet away. Richard Slonneger, enjoying a cigar, helps with clearing away the brush on this hot June afternoon.

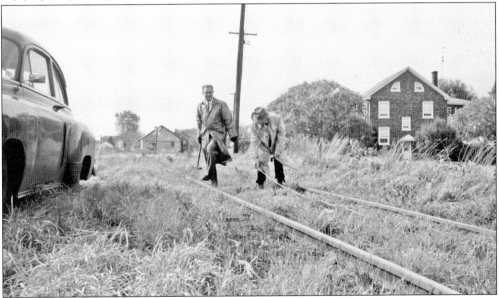

Dressed in suits and ties, Huber Leath (left) and Donald Hallock check out the tracks at their future railroad on a windy day in 1958. With hammers and tape measures in hand, the dapper gentlemen assess the condition of the rails just east of the impassable Route 741 crossing. It is interesting that Strasburg's gauge was once considered unique in America, measuring a half-inch wider than the standard 4 feet, 8½ inches. (Huber Leath Collection, Railroad Museum of Pennsylvania, PHMC.)

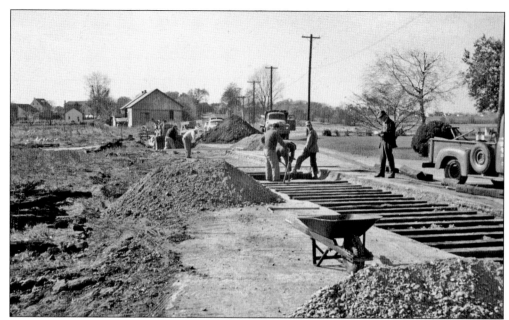

In 1957, the Pennsylvania Department of Highways mistakenly paved over the entire Route 741 crossing, making it impassable by rail. So in the fall of 1958, with the assistance of Roy L. Zimmerman Excavating, the investors had to raise and reballast the rails and then repave the crossing—all at their personal expense. (Huber Leath Collection, Railroad Museum of Pennsylvania, PHMC.)

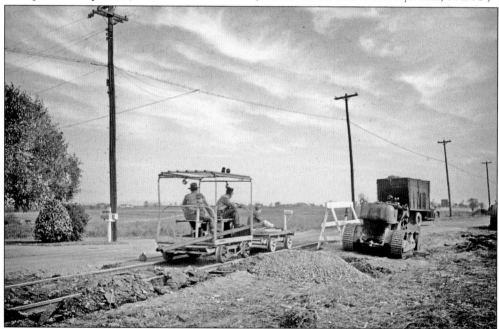

Henry Long (with fedora) and William M. Moedinger ride the four-cylinder Northwestern M-1 track car down to the Route 741 crossing in this fall 1958 photograph. Along for the ride is Moedinger's son, Linn, seated behind his father. Just like his father, Linn W. Moedinger would assume the helm of the Strasburg Rail Road and eventually become the company's longest serving president. (Lynford Swearer Collection, Railroad Museum of Pennsylvania, PHMC.)

While the tracks were being repaired and reconditioned, Plymouth No. 1 was shipped via flatbed truck to the Reading Company Shops in Reading, Pennsylvania. It was reconditioned to ICC operating standards and painted a bright combination of royal blue and yellow. Seen here in late October 1958, No. 1 sports polished brass and a new headlight while awaiting the return trip to Strasburg. Behind it is one of Reading Company's Baldwin AS16 locomotives.

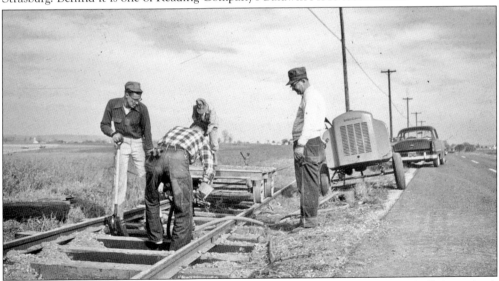

After determining the needed final touches, Huber Leath (right), Winston Gottschalk (on railcar), and Ray LeCates (in plaid), along with an unidentified young man, work to replace a few last crossties. Seen here in November 1958—just days after the sales agreement was signed—the three men are working along Route 741. The land in the distance is now the station area and passenger depot for the Strasburg Rail Road. (Lynford Swearer Collection, Railroad Museum of Pennsylvania, PHMC.)

September 23, 1958

NOTICE

SUBJECT: Strasburg Railroad Meeting

The first Stockholders Meeting of the Strasburg Railroad will be held at 3:00 P.M., Saturday, October 4, 1958 in the private car, "Pequea Valley", in the foundry yard, of the Champion Blower & Forge Company, Lancaster, Penna.

To locate this point go out Harrisburg Avenue to the intersection of Pine St. turn right in a narrow alley between two buildings.

Refreshments will be served after the meeting.

The Strasburg Railroad will be open for your inspection between 11:00 A.M. and 2:00 P.M. on that day and officials will be available to take you a trip over the railroad, leaving from the Homsher Mill.

Very truly yours,

Henry K. Long

The first meeting of the Strasburg Rail Road shareholders was held on October 4, 1958, on Henry K. Long's private railcar, *Pequea Valley*, housed at Long's company, Champion Blower & Forge. Shown here is the original shareholders notice from September 23, 1958, given to PRR vice president John E. Chubb, who was one of the first investors in the revived Strasburg Rail Road. The Strasburg Rail Road was officially sold to the group of investors on November 1, 1958.

The modern incarnation of the Strasburg Rail Road Company was organized in a most unusual fashion with one president and 23 vice presidents. Initially, about 100 shares were issued, which raised $22,500 toward the $18,000 sale price of the railroad. It is interesting that the 1958 shares were issued from Strasburg Rail Road's original 1851 stock book. That historic book continued to be used until the stock split of 1970, at which time a new series of stock was issued. Isaac Hershey and his wife, Esther, received stock No. 1 under the new Strasburg Rail Road Company on November 25, 1958.

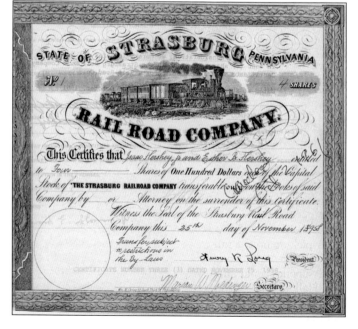

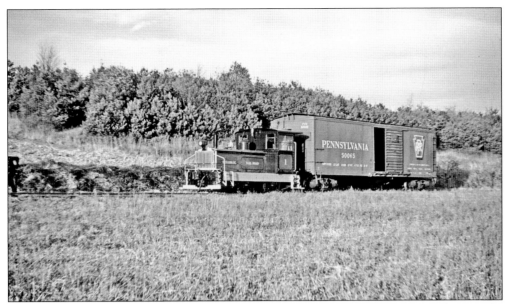

The first run under the revitalized Strasburg Rail Road Company occurred on November 8, 1958, with Huber Leath and Henry Long serving as engineer and conductor, respectively. They left Strasburg at 2:00 p.m. in Plymouth No. 1 bound for Leaman Place to pick up "railroad supplies" (splice bars, spikes, track bolts, and other equipment) that arrived on PRR class X29 boxcar No. 50065, dispatched from the Pennsylvania Railroad's Lucknow shops. (Huber Leath Collection, Railroad Museum of Pennsylvania, PHMC.)

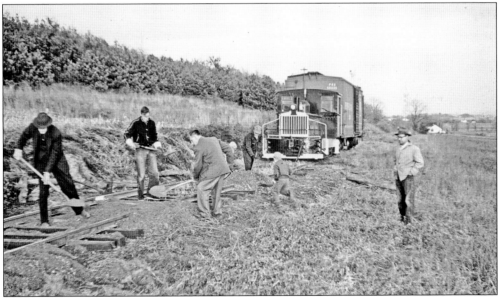

After picking up the railroad supplies from the interchange on November 8, 1958, the freshly painted Plymouth locomotive and PRR boxcar No. 50065 sat at the future Groff's Grove so that those supplies could immediately be put to good use. This photograph shows, from left to right, Don Hallock, an unidentified young man, William Moedinger, Huber Leath, and a young Linn Moedinger filling ballast while Henry Long keeps a watchful eye. (Lynford Swearer Collection, Railroad Museum of Pennsylvania, PHMC.)

#1 DATE	#2 TIME OUT	#3 IN	#4 ENGINEER	#5 CONDUCTOR	#6 UNIT USED	#7 CARS MOVED MARKS	#8 LOADED	#9 EMPTY	#10 DISTANCE TRAVELED MILES	#11 PURPOSE OF T...
1/8/58	2:00 P.M.	4:00 P.M.	Leath	Long	#4	P.R.R.	50065		9	Railroad Sup...
1/9/58	1:00 P.M	4:45 P.M.	Leath	Swearer	#1	P.R.R / S.RR		50065 W-04	9	Return Car
1/11/58	8:55 P.M	10:35 P.M	Moedinger	Leath	#1	G&O	283970		9	Loaded Fea...
1/15/58	7:00 A.M	9:10 A.M	Leath	Moedinger	#1	C&O		283970	9	Returned Fred C
1/20/58	6:30 P.M.	8:30 P.M	Moedinger	Leath	#1	GBW	15052		9	Inbound Frei...
1/22/58	8:15 A.M	2:30 P.M	Leath	Moedinger	#1	GBW		15052	9	Return Empty
1/1/58	10:15 A.M	1:15 P.M	Moedinger	Long	#1				9	Maintenance
1/23/58	8:15 P	10 P.M	Moedinger	Leath	#1	C&EI	64152		63	Inbound Fei...
1/14/58	7:00	8:55 P.M	Leath	Moedinger				64152	9	Out Freig...
2/1/58	10:30 A	11:30 A	Moedinger	Long	#1				9	Maintenance
2/10/58	11:50 A	12:30 P	Moedinger	Gottschalk	#1	CRNP	24118		9	In F
2/18/58	12:30 P	2:45 P	Leath	Hallock	#1	CRNP		24118	9	R E
2/19/58	2:30 P		Leath	Moedinger	#1				5	
2/29/58	12:00 N	1:30 P	Leath	Hallock	#1				9	New Ser...
7/30/58	1:45 P	3:40 P	Leath	Hallock	#1	S.RR	W04	W04	9	Clearan...
7/30/58	6:30 P	9:30 P	Moedinger	Leath	#1	S.RR	90849	90849	9	First Pass...
1.CC.	Mileage Report								12 miles	JHLeath
1/?/59	1:30		Leath	Hallock	#1	S.RR	90849		18	Playing
1/8/59	7:40 P	9:40 P	Moedinger	Leath	#1	P&R/S.RR	98893	335287 COACH	9	1 F
1/?/59	3:00 P	4:15 P	Leath	Long	#1	SRC...	90849	908...	9	Out Frei...

The first page of Strasburg Rail Road's train registers is seen here, beginning on November 8, 1958. This train register details Strasburg's operations through March 1966 and is filled with names and signatures of company legends, such as Bowman, Hallock, Kline, Leath, Moedinger, Solomon, and Swearer. Strasburg's collection of train registers now encompasses an information-packed 10 volumes.

The view from the Plymouth's cab as it approaches Cherry Hill is seen in this fall 1958 photograph. The weeds and brush had been cleared enough to make the tracks passable, but a lot of hard work was required before the tracks could be brought up to proper standards for a fully functioning railroad. The farm in this view, then owned by Melvin and Polly Stoltzfus, is now part of Cherry Crest Adventure Farm. (Huber Leath Collection, Railroad Museum of Pennsylvania, PHMC.)

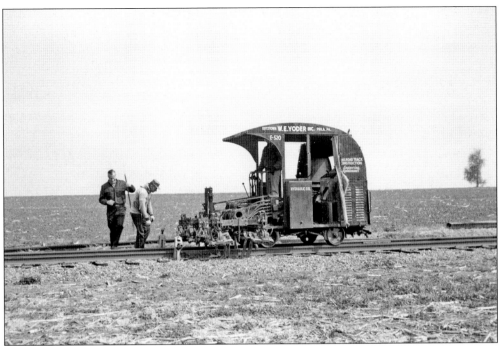

W.E. Yoder Inc., a railroad track contractor from Kutztown, Pennsylvania, served the Strasburg Rail Road as the go-to track work subcontractor almost from the very beginning of operations. Yoder's unique maintenance-of-way contraption is seen in this undated photograph. (Huber Leath Collection, Railroad Museum of Pennsylvania, PHMC.)

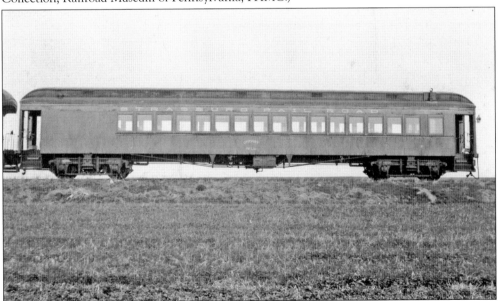

The first passenger car obtained by the new management was a Philadelphia & Reading (P&R) Railroad air brake instruction car. The rebuilt 1911 closed vestibule coach was retired from the Reading on December 2, 1958, and donated to Strasburg through an arrangement facilitated by Huber Leath. The coach arrived at Strasburg later that month to be repainted and retrofitted with bus seats. The car was used during an unexpected test passenger run on December 30, 1958.

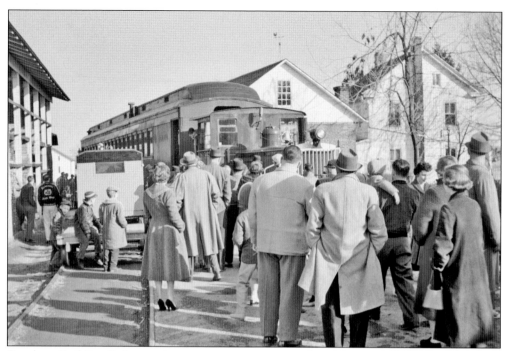

Strasburg Rail Road's first paying passenger run in more than 30 years pulled out of the depot on January 4, 1959, at 1:00 p.m. with Huber Leath as engineer and Don Hallock as conductor; 175 tickets were sold during that first day of passenger operations. This photograph shows one of the first passenger runs returning from Paradise in early 1959. (Huber Leath Collection, Railroad Museum of Pennsylvania, PHMC.)

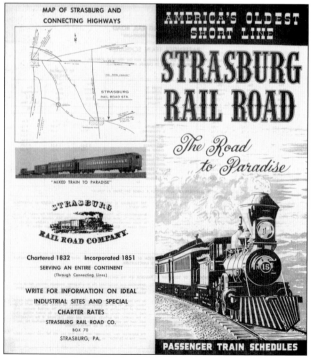

To advertise the newly reinstated passenger service, the Strasburg Rail Road's first promotional brochure was distributed for the spring 1959 tourist season. Seen here is that first brochure (albeit in black and white) advertising the twice-daily departures from Strasburg on weekends and the 7:00 p.m. departures on Tuesdays and Thursdays. The brochure's interior states, "future plans call for additional antique equipment, including a real steam 'Casey Jones' locomotive and reconstruction of the ancient passenger stations."

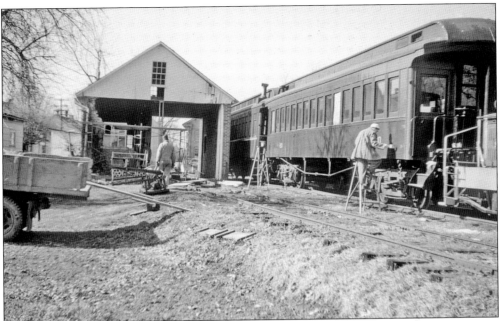

Because of the high demand for rides, the Strasburg Rail Road had to expand its one-car coach fleet. The company's second coach was the open-vestibule Maryland & Pennsylvania (MA&PA) No. 20, which the company purchased from the Baltimore Chapter of the NRHS for $300. This photograph shows volunteers working quickly to repaint the coach in dark green Reading livery before its inaugural run at Strasburg. (Lynford Swearer Collection, Railroad Museum of Pennsylvania, PHMC.)

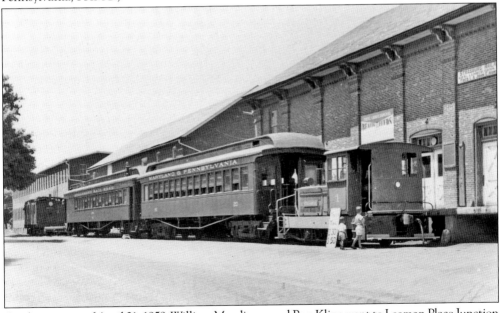

On the evening of April 21, 1959, William Moedinger and Ben Kline went to Leaman Place Junction to pick up MA&PA No. 20. Less than a week after its arrival, the coach was ready for its inaugural run on Sunday, April 26, 1959. The coach is seen here coupled to the Plymouth locomotive on its first day of passenger service, when 250 passengers rode the train over two roundtrips.

STRASBURG RAIL ROAD COMPANY
GENERAL OFFICES, STRASBURG, PA.
PASS

1959 - 60 - 61

No. 427

On Passenger and Freight Trains
OVER ENTIRE SYSTEM
until December 31, 1961, unless otherwise ordered, and
subject to the conditions stated on the back hereof.

PRESIDENT

VICE PRESIDENT
Issuing Officer

Beginning in 1959, all the employees and shareholders received three-year passes—each one signed by Henry K. Long—which entitled them to complimentary rides—passenger and freight—on the railroad. Unissued pass No. 427 from 1959 is shown here.

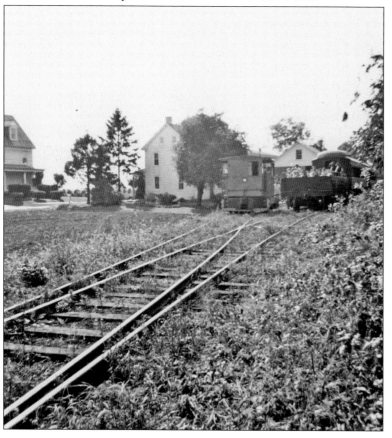

A rare view behind the original engine house in this summer 1959 photograph shows Plymouth No. 1 performing the runaround before pushing the consist to the Homsher Mill for passengers to disembark. SRC No. 102, the 1913 ex-PRR No. 335287 wooden gondola with longitudinal benches, served as an open car. The gondola was donated to the Strasburg Rail Road by PRR assistant vice president and SRC vice president Max Solomon II.

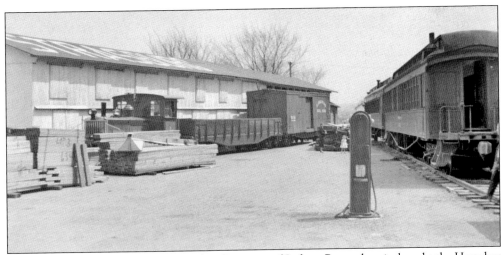

In the spring of 1959, I.B. Graybill Lumber Company of Refton, Pennsylvania, bought the Homsher Mill. This 1959 photograph shows the Plymouth sitting in the lumberyard just east of the passenger depot. The locomotive is coupled to SRC's wooden gondola ex-PRR No. 335287 and boxcar SRC W-04. SRC coaches No. 58 and No. 59 sit on the main track. (Huber Leath Collection, Railroad Museum of Pennsylvania, PHMC.)

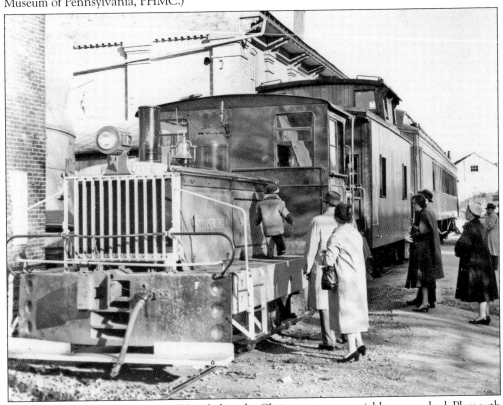

As 1959 wound down, business still bustled, as the Christmas season quickly approached. Plymouth No. 1, still painted in a Reading blue livery, sits in front of the former Homsher Mill in November 1959. Passengers are eagerly waiting to embark on a journey to Paradise with PRR caboose 476087 and the Reading coach car (now numbered SRC No. 58).

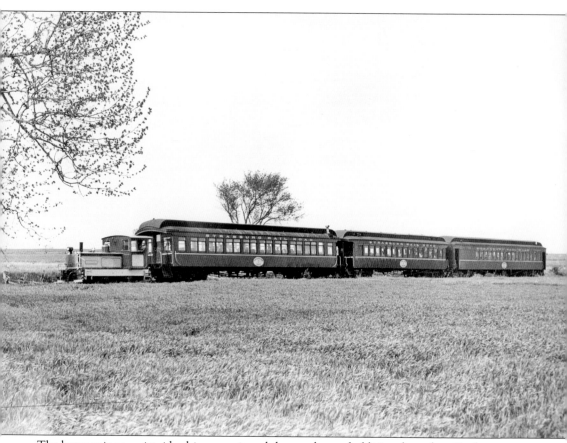

The burgeoning tourist ridership necessitated the purchase of additional coaches. By the summer of 1960—a little more than a year after resuming passenger service—the Strasburg Rail Road had expanded its fleet of wooden passenger cars threefold. Plymouth No. 1, resplendent in its new maroon and yellow livery, pulls the entire passenger fleet in this May 1960 photograph. This was the last summer that the Plymouth was the main motive power. By September, steam would once again reign on the rails at Strasburg.

Three

STEAM RETURNS
TO STRASBURG

Steam returned to the Strasburg Rail Road in the fall of 1960 after a 34-year hiatus. Canadian National No. 7312, a 1908 0-6-0 Baldwin locomotive, was the first steam locomotive to be returned to ICC service in the United States when it carried its first passenger run to Paradise in September 1960. The railroads were divesting their rosters of serviceable steam engines and replacing them with diesel-electrics; the anachronistic idea of reviving and running steam locomotion for revenue passenger service was antithetical to the trend at the time. Returning a steam locomotive to ICC service was a huge accomplishment for Strasburg. The buzz it created among tourists and railfans alike spurred visitation even faster at the already popular attraction.

Except for the first two seasons of tourist operations, Strasburg has exclusively run steam for its passenger trains. In fact, the success of steam motive power, as well as the company's dedication to preserving and operating steam locomotives, prompted the acquisition, restoration, and operation of six additional steam engines during the next four decades. (For a brief six years—1983 to 1989—the Strasburg Rail Road had five serviceable steam locomotives on its roster when PRR No. 7002, an E-7s 4-4-2 built in 1902, ran on Strasburg's rails.) Strasburg's unwavering commitment to steam locomotion is unique among fellow heritage railways.

Besides the unrivaled roster of steam locomotives, Strasburg has been home to unique rail equipment—diesel, gasoline, or otherwise—throughout the years that helped provide a glimpse into early-20th-century short line railroading. From the four-cylinder Northwestern railcar to the 1926 gasoline-powered Plymouth locomotive, many unique pieces of railroad locomotion have run the rails at Strasburg.

Often overlooked yet equally important is Strasburg's dedication to wooden passenger cars. Strasburg has the country's largest fleet of fully restored, historic wooden passenger coaches from various North American railroads.

Strasburg's world-renowned reputation for excellence in the steam railroading industry—specifically among its motive power and passenger cars—is one of the reasons the Strasburg Rail Road has been called the gold standard of tourist railroads.

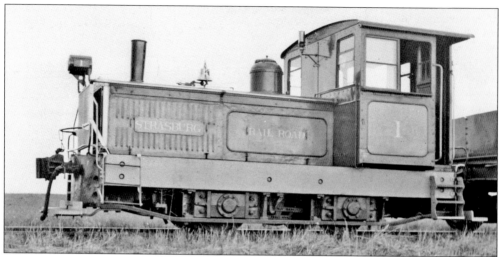

After determining that steam was too expensive to run on its very limited freight income, the Strasburg Rail Road was one of the first railroads in the United States to completely divest itself of steam motive power. In October 1926, the Strasburg Rail Road purchased a brand new, 20-ton, model HL Type 3 gasoline-powered Plymouth locomotive manufactured by the Fate-Root-Heath division of the Plymouth Locomotive Works of Plymouth, Ohio. This photograph shows the Plymouth shortly after its repaint at the Reading shops in October 1958. The Plymouth remains today on the company's roster of serviceable engines.

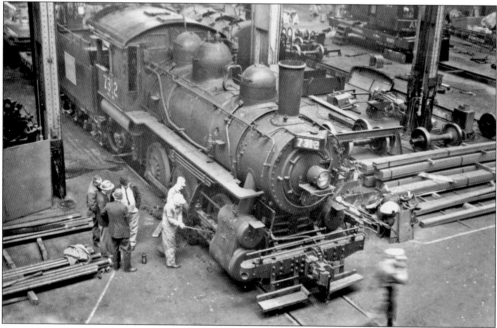

As early as 1959, the executives of the Strasburg Rail Road wanted to reinstitute steam on their short line, so when Bud Swearer learned that the Canadian National Railway (CNR) 0-6-0 No. 7312 was slated for the scrap heap in June 1959, negotiations began between CNR and Strasburg to move it to Pennsylvania. In April 1960, SRC officials Stewart Armstrong, Don Hallock, Huber Leath, Bud Swearer, and John Sullivan traveled to Canadian National's shops in Stratford, Ontario, to personally inspect the locomotive.

After three months of negotiations, ex-CNR No. 7312 was sold to several Strasburg Rail Road executives in September 1959 for $3,200; they, in turn, leased the locomotive to the railroad until 1968. The original bill of sale from 1959 is seen here. When the balance of the sale price was paid off, the locomotive was shipped by rail to Strasburg. It arrived on June 15, 1960. Its sale and relocation to the upstart Strasburg Rail Road garnered some much-appreciated media attention along the way.

CNR No. 7312, later renumbered as SRC No. 31, was built by Burnham, Williams & Company (later Baldwin Locomotive Works) in 1908 and spent the first 50 years of its life on the Grand Trunk Railway and later as a switcher on the merged conglomerate of the Canadian National, which renumbered it as No. 7312 in January 1957. The locomotive's c. 1957 Canadian National number plate is seen here.

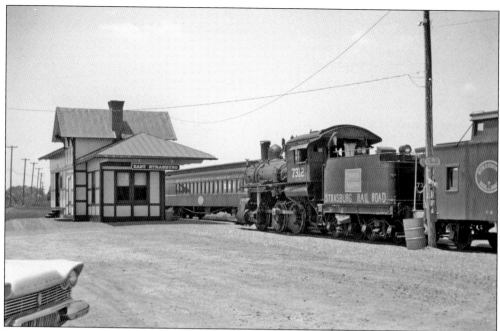

During the summer of 1960—while it was waiting for official papers from the ICC—No. 7312 sat on static display just east of the newly relocated East Petersburg Station. No. 7312 with its hand-painted Strasburg Rail Road tender can be seen in this summer 1960 photograph. It was only a matter of weeks until steam ran again at Strasburg. (Huber Leath Collection, Railroad Museum of Pennsylvania, PHMC.)

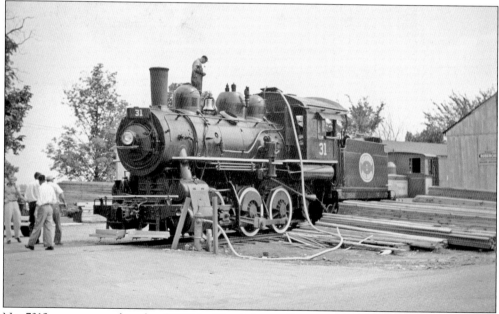

No. 7312—now renumbered as SRC No. 31— is hurriedly prepared for its first passenger run on September 1, 1960, in this photograph taken at the former Homsher Mill. No. 31 was the first steam locomotive returned to ICC service in the United States. (Huber Leath Collection, Railroad Museum of Pennsylvania, PHMC.)

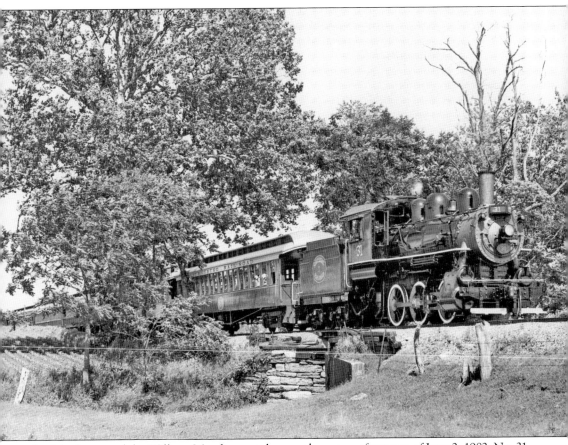

In this photograph by William Moedinger, taken on the sunny afternoon of June 2, 1982, No. 31 crosses the railroad's only bridge, the Pumpkinville Turnpike bridge, as it ascends the 1.5-percent grade back to East Strasburg. In November 2011, the increased modern freight traffic necessitated that the original 19th-century stone bridge be replaced with a historic-looking yet contemporary structure. Guests are still asked to "lift their feet" as the train crosses the bridge during the ride. (Courtesy of Linn Moedinger.)

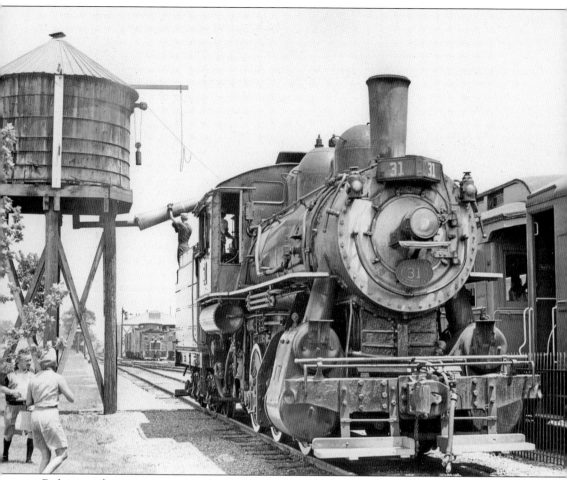

Before coupling up to its consist for another run to Paradise, No. 31's tender is refilled with water in this classic late 1960s photograph by William Moedinger. The wooden water tower, which by 1986 would be replaced with a modern metal tank, was used for years in nearby Bird-In-Hand, Pennsylvania, before being moving to Strasburg in 1965. (Courtesy of Linn Moedinger.)

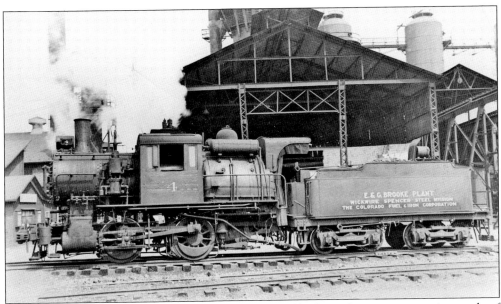

Sometimes called a "Mother Hubbard" style, the camelback configuration is a unique style of locomotive that Burnham, Williams & Company (later Baldwin) built in the early 20th century. Camelback 0-4-0 No. 1187 (later No. 4), a P&R class A4b built in 1903, served as a switcher at the E. & G. Brooke Plant—a subdivision of the Colorado Fuel & Iron Company—in Birdsboro, Pennsylvania, from 1946 until its retirement in 1962. Shown here is No. 4 at the Birdsboro plant in 1954. (Lynford Swearer Collection, Railroad Museum of Pennsylvania, PHMC.)

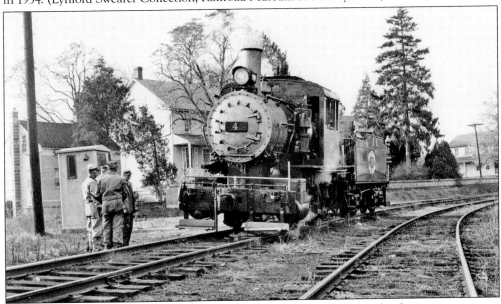

When the Strasburg Rail Road purchased No. 4 in 1962 for $8,500—thanks to an agreement through SRC's Ray Buckwalter—it was one of only three remaining camelbacks in the United States. On November 8, 1962, the fourth anniversary of the first run under the revived Strasburg Rail Road, No. 4 ran under its own steam from Birdsboro to its new home in Strasburg. This photograph shows SRC's Huber Leath and John Bowman along with Reading employees taking a break at Lancaster Junction on the Reading branch.

Originally built as No. 1187 in March 1903, it was renumbered as No. 4 in 1946 by the E. & G. Brooke Plant. The No. 4 number plate is shown here. No. 4 ran at Strasburg mostly as a yard shifter, pulling trains through the passenger depot area during the runaround in the depot, from 1962 to 1967. After retirement in May 1967, the engine spent the rest of its time on static display at Strasburg Rail Road and at the Railroad Museum of Pennsylvania.

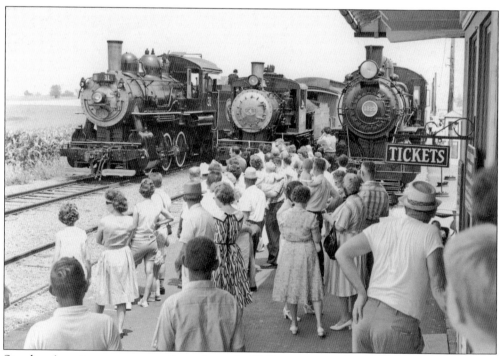

Strasburg's entire steam roster from the early 1960s is seen in this early summer mid-1960s photograph. Crowds of passengers surround the station waiting to board the "Road to Paradise" as switcher No. 4 brings SRC No. 31's passenger car consist into the depot area. Ex-PRR No. 1223 is on static display next to the station shortly before it, too, would be running under steam beginning in 1965.

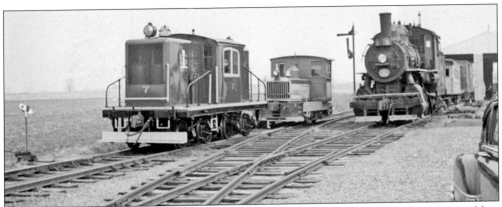

Originally built by General Electric in 1915 for the University of Michigan and later sold to the Warwick Railway in Warwick, Rhode Island, No. 7 (formerly No. 100) reentered service at Strasburg in October 1960 after being converted from a slant-hood gasoline-electric engine to a straight-hood diesel-electric engine. No. 7 was used primarily for freight and switching purposes—occasionally for passenger service—from 1960 until its retirement in 1963. No. 7 is seen here alongside Plymouth No. 1 and No. 31 around 1961. (Huber Leath Collection, Railroad Museum of Pennsylvania, PHMC.)

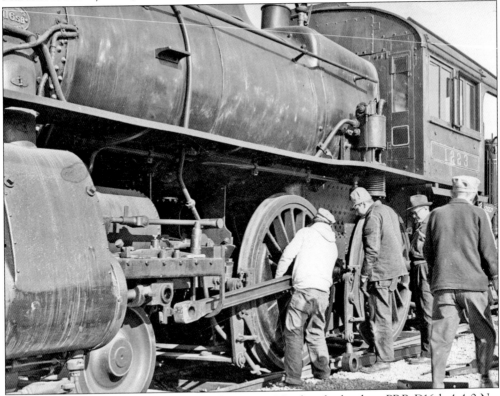

Delivered from the PRR's Historical Collection in Northumberland, ex-PRR D16sb 4-4-0 No. 1223 arrived in Strasburg in the fall of 1960 and sat on static display for the next four years. From left to right, Ben Kline, Bud Swearer, and Henry Long inspect No. 1223's driving rods in this late fall 1960 photograph, shortly after the locomotive's arrival at Strasburg. (Lynford Swearer Collection, Railroad Museum of Pennsylvania, PHMC.)

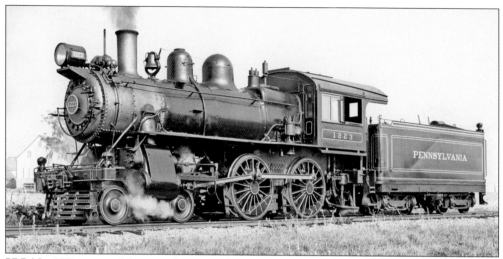

PRR No. 1223 is one of the most famous and storied locomotives to ever run at Strasburg. Built by Pennsylvania Railroad's Juniata shops in 1905, D16sb No. 1223 was assigned first to the Northern Central Railroad, then the West Jersey & Seashore Railroad, and finally on the Pennsylvania's Delmarva Division before retirement from the PRR in 1950. In 1939, No. 1223 made its Hollywood debut in *Broadway Limited*. Its most famous role came in 1969, when it appeared in *Hello, Dolly!* After four years on static display at Strasburg, No. 1223 is prepared for one of its first runs at Strasburg in this mid-August 1965 photograph. Note that "Strasburg Rail Road" was not yet painted under the cab window.

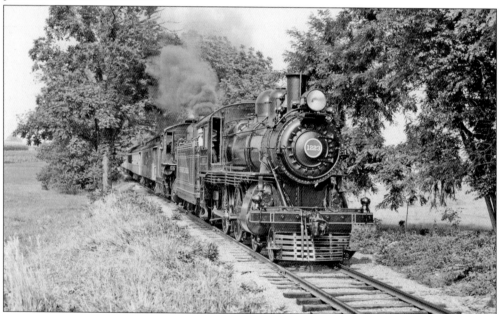

The iconic PRR pinstripe graced Strasburg's rails by happenstance when then-PRR president Allen Greenough gave his unexpected approval for No. 1223's return to operation. Greenough's famous "Fix 'em up!" comment to Huber Leath and Don Hallock got the wheels in motion for the locomotive to return to steam—this time at Strasburg. This photograph by acclaimed photographer Gordon Roth shows one of No. 1223's first passenger runs in August 1965 with Huber Leath as engineer. Notice that "Strasburg Rail Road" was not yet painted under the cab window. (Courtesy of Linn Moedinger.)

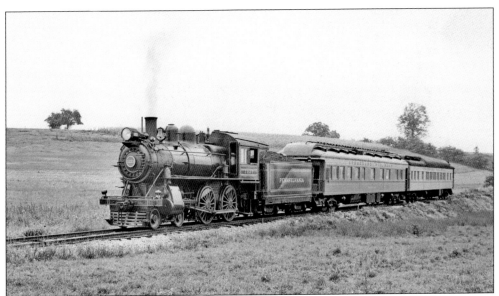

From the beginning, No. 1223 was a railfan favorite. In this late summer 1965 photograph by William Moedinger, No. 1223 pulls a passenger extra composed of the *Paradise* business car (the 1913 Philadelphia & Reading car No. 10) and the *Pequea Valley*, a 1920 Pullman car used on the Pittsburgh & Lake Erie Railway, on the rear. The *Pequea Valley* was purchased as a private railcar in 1958 by several SRC executives, including Irl Daffin, Henry Long, and Max Solomon. The first Strasburg shareholders meeting was held on this car on October 4, 1958. (Courtesy of Linn Moedinger.)

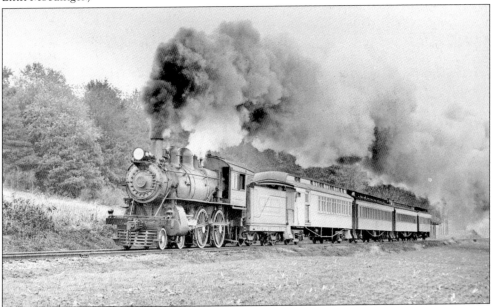

Hello, Dolly! was filmed in Garrison, New York, during the summer of 1968. For a good while after the filming, No. 1223 retained the somewhat outlandish New York Central & Hudson Railroad (NYC&HR) livery strictly for publicity purposes. In this c. 1970 photograph, No. 1223, still wearing the NYC&HR livery, is hauling a four-car consist composed of three of the four coaches used in the movie (No. 59, No. 60, and No. 62). The train is passing Groff's Grove.

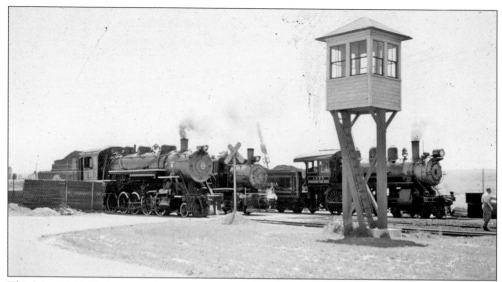

This May 27, 1967, photograph captures a rare moment in Strasburg's history, as three of Strasburg's four serviceable steam locomotives—all under steam at the same time—pose at the engine house crossing. That day also marked the last time that camelback No. 4 (center) ran under steam as it passed the baton to Strasburg's newly acquired ex–Great Western Railroad No. 90 (left). (Ellis Bachman Collection, Railroad Museum of Pennsylvania, PHMC.)

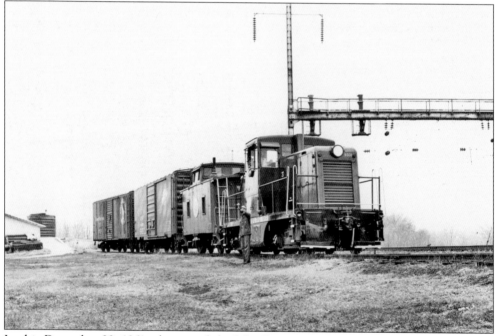

In this December 23, 1961, photograph by John Bowman, taken at Eby's siding in Paradise, Strasburg's 44-ton diesel switcher, PRR No. 9331, takes Chicago & North Western Railroad boxcar No. 24720 and Great Northern Railway boxcar No. 48772 back to Leaman Place Junction. Huber Leath and Henry Long served as engineer and brakeman, respectively. PRR No. 9331 was leased from the Pennsylvania from 1961 to 1966 and was owned outright by Strasburg from 1967 to 2011, when it was sold to Walkersville Southern Railroad.

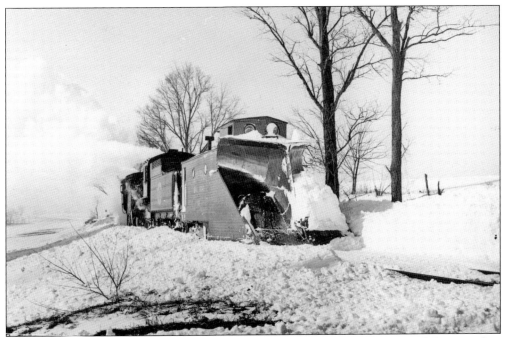

Built by the Russell Snowplow Company sometime after 1902, Strasburg acquired the snowplow (numbered as SRC No. 66) in 1966. The snowplow is often used to clear the line when the railroad receives significant snowfall. SRC No. 66, pushed by a doubleheader led by No. 31 and coupled to No. 90, is just west of Carpenter's Crossing in this February 9, 1978, photograph by John Bowman.

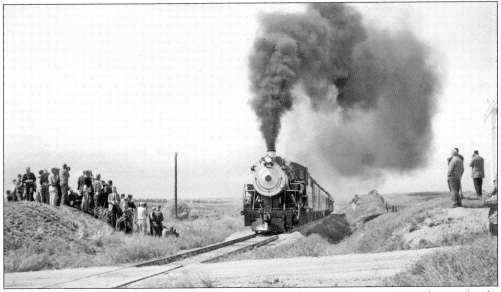

Great Western Railroad (GW) No. 90, a 2-10-0 Decapod-class engine, was GW's largest freight locomotive on its line. Built in June 1924 by the Baldwin Locomotive Works in Philadelphia for the Loveland, Colorado-based railroad, GW No. 90 was used primarily to haul sugar beets. No. 90 was a star even when it ran in Colorado; here, railfans photograph it coming through the flats in the early 1960s. (Huber Leath Collection, Railroad Museum of Pennsylvania, PHMC.)

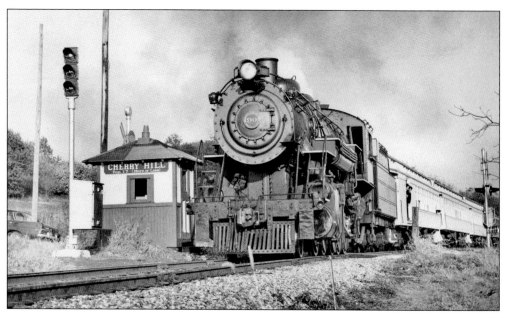

During an excursion trip out west in 1963, SRC's Huber Leath and John Bowman first learned about Great Western No. 90 and expressed interest in purchasing it if the locomotive became available. When GW No. 90 was for sale, Huber Leath jumped at the chance and helped facilitate a deal to purchase the 2-10-0 locomotive in April 1967 for a mere $21,000. Shown here is No. 90 passing Cherry Hill in the early 1970s.

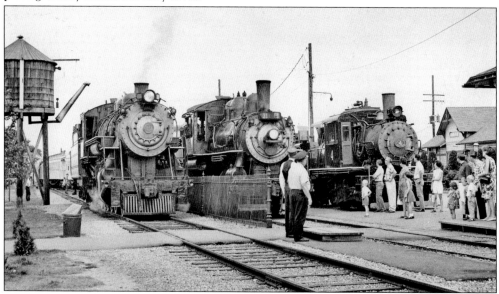

Three iconic Strasburg locomotives are seen in this early 1970s photograph by William Moedinger. Passengers eagerly wait to board the next train as No. 31 pulls its consist into the passenger depot and No. 90 waits patiently on the adjacent track. Camelback locomotive No. 4 sits on static display on the Repair in Place (RIP) track next to the station. The iron fence separating the two main tracks once surrounded Lancaster City's water reservoir on East King Street. The fence, along with accompanying lampposts, was given to the Strasburg Rail Road in 1964. (Courtesy of Linn Moedinger.)

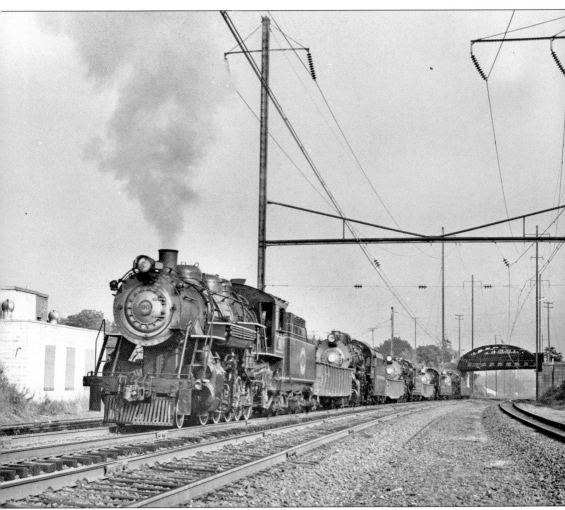

In this rare photograph by William Moedinger, SRC No. 90 pulls the "train of trains" en route to the newly established Railroad Museum of Pennsylvania's collection on the morning of August 7, 1969. These four PRR steam locomotives mark the first of three trips No. 90 would make that year specifically to bring retired Pennsylvania-related railroad equipment destined for the new railroad museum. It was also one of No. 90's first tonnage challenges since its days of hauling sugar beets in Colorado. (Courtesy of Linn Moedinger.)

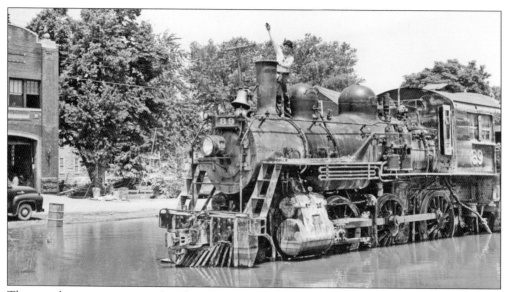

The next locomotive to join Strasburg's roster was ex-Canadian National Railway Mogul-class 2-6-0 No. 89. In this well-known photograph from July 5, 1972, No. 89 sits in receding floodwaters at Penn Central's Buttonwood Yard in Wilkes-Barre, Pennsylvania. A shirtless Linn Moedinger stands on top of the locomotive and estimates where the high-water mark was—three feet above No. 89's smokestack. Moedinger retreated to the second floor of the firehouse (left) when the floodwaters from the Susquehanna River rose too high. (Courtesy of Linn Moedinger.)

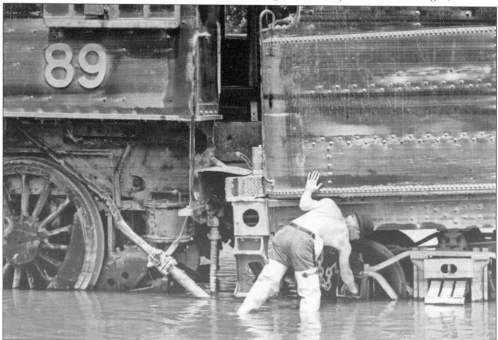

Built by the Canadian Locomotive Works in 1910 for the Grand Trunk Railway, ex-CNR No. 89 (formerly No. 911) arrived at Strasburg on July 15, 1972, after a harrowing encounter with Tropical Storm Agnes during its 555-mile trip from Bellows Falls, Vermont. Here, Linn Moedinger checks out one of the tender's trucks as the floodwaters recede on July 2, 1972. (Courtesy of Linn Moedinger.)

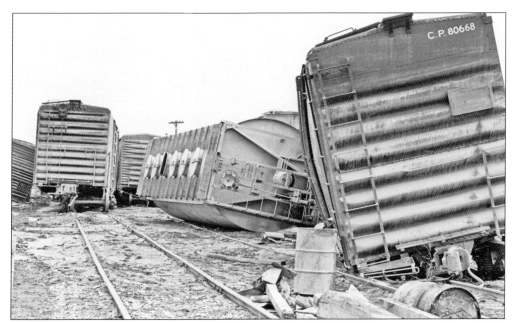

Agnes, the first named hurricane of the 1972 season, hit the Mid-Atlantic states on June 21–23, wreaking the most havoc in Pennsylvania through unprecedented flooding of main arterial rivers between Scranton and Lancaster. Coincidentally, the storm hit Wilkes-Barre during No. 89's layover at the Buttonwood Yard. This picture shows how powerful the floodwaters were; the freight cars were tossed around like sticks. However, thanks to No. 89's weight, it stayed upright the entire time. After the cleanup, No. 89 left Buttonwood Yard on July 10, 1972. (Courtesy of Linn Moedinger.)

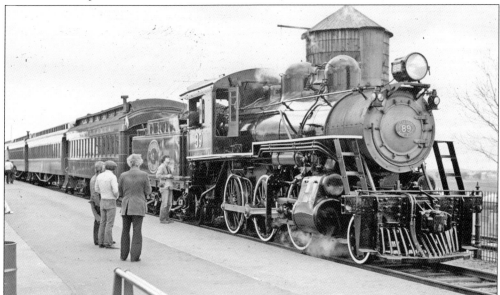

For one week after its inaugural passenger run on March 14, 1973, ex-CNR 2-6-0 No. 89 ran facing east on Strasburg's rails; it was reoriented to the west on the Railroad Museum of Pennsylvania's turntable on March 21, 1973. This rare photograph from the third week of March 1973 shows the east-facing locomotive with a four-car consist, including PRR coach No. 3556, positioned in front of the wooden water tower. (Ellis Bachman Collection, Railroad Museum of Pennsylvania, PHMC.)

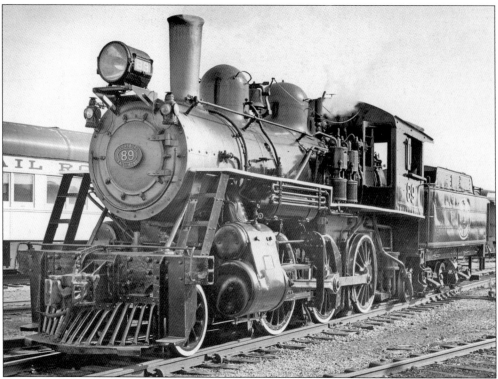

SRC No. 89, with white-walled 63-inch drivers, gleams in the morning sun as its sits on the engine house lead in this pre-1979 photograph. After six and one-half seasons of running at Strasburg (March 1973–July 1979), No. 89 took a 10-year hiatus while it underwent a complete mechanical overhaul and rebuild. It returned to Strasburg's rails in 1988.

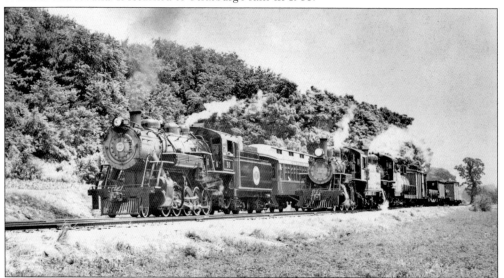

In this most unusual scene at Groff's Grove, taken by William Moedinger in 1977, SRC No. 89 leads a doubleheader freight train with the other SRC-owned Canadian National locomotive—SRC No. 31. SRC's Decapod class No. 90 with a passenger consist passes the freight train on track No. 1 as it leads its cars back to East Strasburg. (Courtesy of Linn Moedinger.)

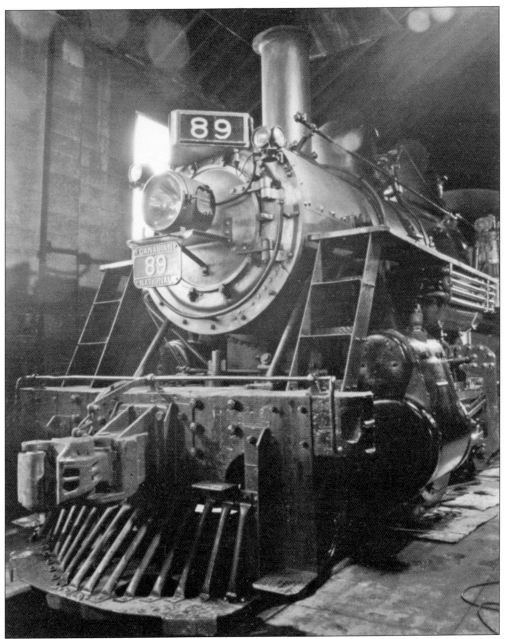

Between 1999 and 2003, No. 89 underwent mechanical and cosmetic work at the hands of the skilled machinists in Strasburg Rail Road's shops. This photograph from 2004 shows the locomotive in the engine house sporting a c. 1950s Canadian National livery with a center smokebox-mounted headlight.

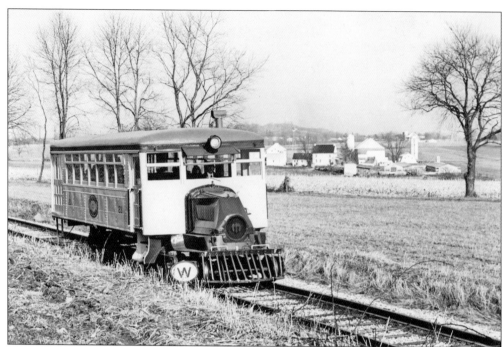

Strasburg's former Railbus No. 21, driven by Huber Leath, is seen in this 1969 photograph (below) shortly after SRC acquired the unusual rail vehicle in April. The gasoline railbus was built by Mack Trucks of Allentown, Pennsylvania, in November 1921 and ran on several railroads, including the Pennsylvania Railroad (1928–1931). Railbus No. 21 remained on Strasburg's roster of serviceable motive power until its retirement during the decade after its purchase. Today, the railbus is housed across the street at the Railroad Museum of Pennsylvania.

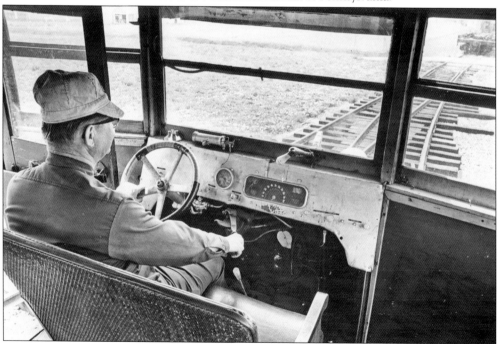

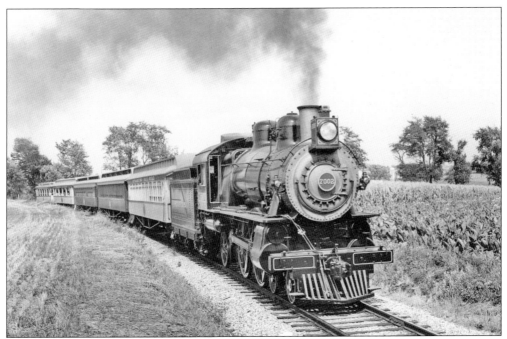

When it was still running at Strasburg, PRR No. 7002, a 4-4-2 locomotive built by the Juniata shops in 1902, was the oldest steam locomotive still in regular service in the United States. No. 7002 was on loan from the Commonwealth of Pennsylvania from 1983 through the end of 1989. Like its sister, No. 1223, cost-prohibitive repairs and the end of a short-term lease led to its retirement. Seen in this August 1983 photograph by Ken Murry is the locomotive's inaugural run on Strasburg's rails, coming around Long curve.

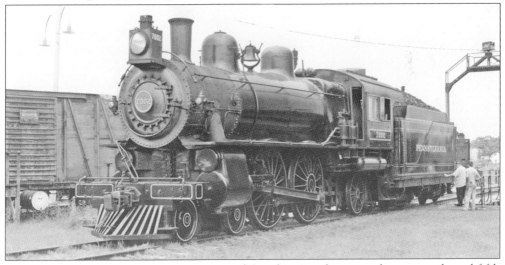

For the nearly six years that No. 7002 graced Strasburg's rails, it was the unprecedented fifth serviceable steam locomotive on the company's roster, proudly running alongside its PRR sister No. 1223. An ultrasonic boiler test performed at its annual inspection revealed a thin roof-sheet in the firebox, which subsequently led to retirement to the Railroad Museum of Pennsylvania in 1989, where it remains today. This photograph by Earl Kinard shows No. 7002 inching off the museum's turntable on an early morning in August 1985.

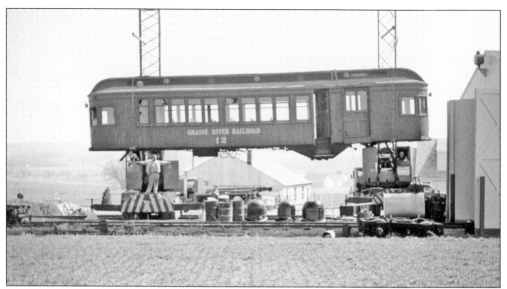

Lancaster, Oxford & Southern (LO&S) Railroad's internal combustion railcar was built in 1915 by the Sanders Machine Shop in Havre de Grace, Maryland, and is the only kingpin drive car ever built. Originally designed as a narrow-gauge railcar, it was converted to standard gauge in 1918 after its sale to the Grasse River Railroad. Strasburg Rail Road's Winston Gottschalk purchased car No. 10 from Grasse River in 1962 for $2,000. Here, two cranes position LO&S car No. 10 to be reunited with its trucks on April 5, 1962. (Huber Leath Collection, Railroad Museum of Pennsylvania, PHMC.)

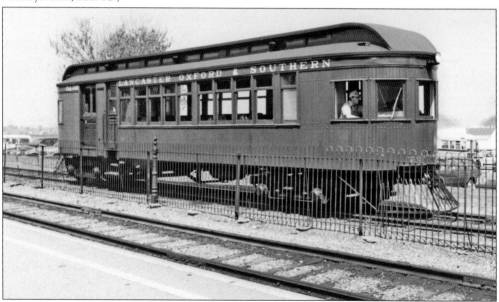

When the LO&S car arrived at Strasburg in April 1962, it lacked the proper ICC papers to operate, but after it was rebuilt to operating standards, it was leased to several heritage railroads, starting in 1976 before returning to Strasburg in 1984. The car first ran on Strasburg's rails from 1985 through 1989 and then again beginning in 1997. It is interesting that the car can operate from either end, and it is often used today during the shoulder tourist season. Engineer James F. Rice is at the controls in this photograph.

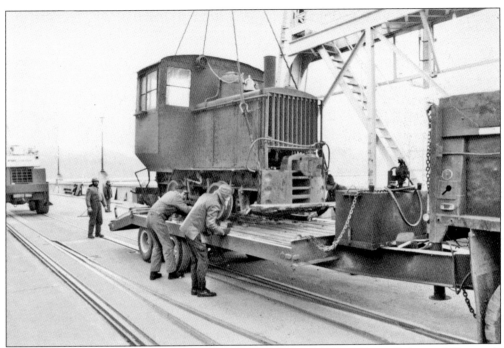

In December 1984, Strasburg purchased a 1930 dinky locomotive—a 10-ton JLA type 2 Plymouth propane-powered (later converted back to gasoline)—from the Safe Harbor Water & Power Corporation for $50. This photograph, taken at Safe Harbor Dam in December 1984, shows the dinky being lifted via crane onto a flatbed truck shortly before leaving for its new home in Strasburg. It is currently used as a small shop switcher.

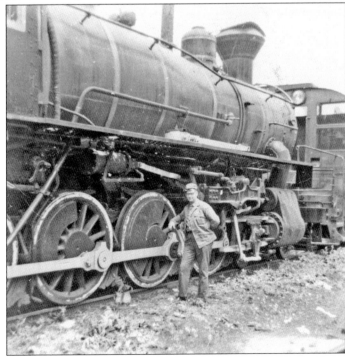

Norfolk & Western (N&W) M-class No. 475 was built in June 1906 as a mainline freight locomotive and served on the N&W for over half a century before being sold to the Virginia Scrap Iron & Metal Company in 1962. In June 1965, Dwight Armagost of Holsopple, Pennsylvania, purchased engine No. 475. The locomotive changed hands three more times before being sold to the Strasburg Rail Road in 1991 for $100,000. Pictured here is Armagost in Roanoke, Virginia, around the time he purchased the locomotive.

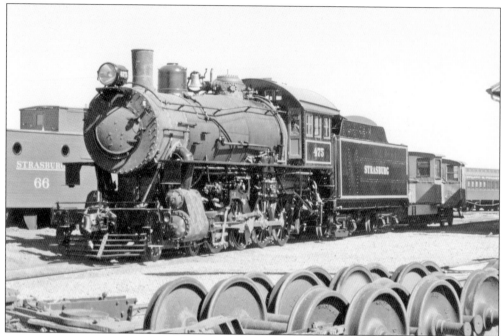

The retirement of PRR Nos. 1223 and 7002 in 1989-1990 left a gaping hole at Strasburg that was quickly filled with the arrival of ex-N&W No. 475 in July 1991. After an extensive $600,000 mechanical overhaul and rebuild led by SRC's chief mechanical officer Linn Moedinger over the next 27 months, No. 475 was ready to grace Strasburg's rails in November 1993. This photograph shows the locomotive behind the engine house in October 1993.

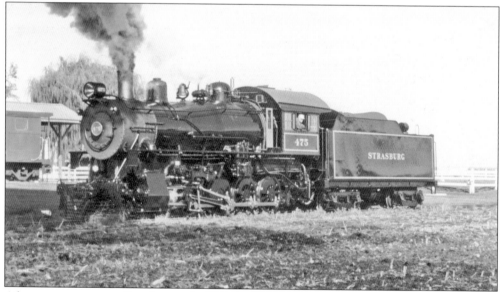

After two test runs earlier that week, SRC No. 475 entered passenger service at Strasburg on Saturday, November 6, 1993, with Linn Moedinger serving as engineer. No. 475 hauled five trips of happy customers to Paradise on its inaugural day. Pictured here is a freshly painted SRC No. 475 on one of the test runs in front of the Red Caboose Motel on November 1 or 2, 1993. No. 475 remains in active service at Strasburg and is the company's second largest locomotive.

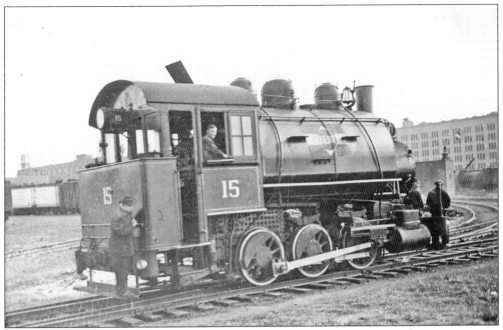

Ex-Brooklyn Eastern District Terminal (BEDT) 0-6-0T No. 15 was built by the H.K. Porter Company in March 1917. Originally built for the Mesta Machine Company in western Pennsylvania, it was later sold to the Brooklyn Eastern District Terminal, which ran it until 1965. No. 15 is the oldest surviving of BEDT's H.K. Porter locomotives and the only one still operating. After changing ownership two more times, the Strasburg Rail Road acquired ex-BEDT No. 15 in March 1998. This c. 1935 photograph shows BEDT No. 15 running at the Brooklyn docks. (Courtesy of Queens Library of New York.)

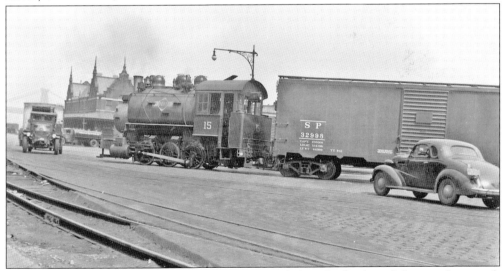

This September 10, 1941, photograph by R. Wingard is believed to be the only known photograph of a BEDT locomotive at the Wallabout Terminal Market and one of the most historically important photographs ever taken of any BEDT locomotive. BEDT No. 15 pulls a boxcar through the intersection of Clinton Avenue and Metz Street. Note New York City's Williamsburg Bridge in the background. (Courtesy of Philip Goldstein.)

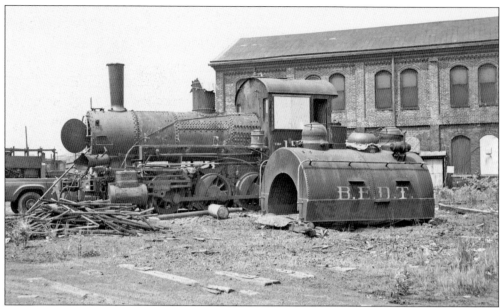

In 1965, Edward Bernard of the South Appalachian Railway purchased BEDT No. 15 for approximately $5,000. This 1966 photograph by B. Yanosey shows ex-BEDT No. 15 sitting on a storage track at the PRR Meadows Yard in New Jersey before moving to the South Appalachian Railway. The saddle tank, flues, and boiler tubes were removed and can be seen sitting next to the locomotive. (Courtesy of David Keller.)

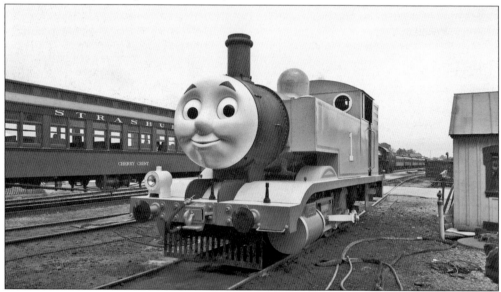

Ex-BEDT No. 15 arrived at Strasburg in May 1998 and, for the following 11 months, underwent an extensive cosmetic and mechanical rebuild to resemble the famed Thomas the Tank Engine. Shown here is the locomotive after the rebuild. To date, it is the only fully functioning, standard-gauge Thomas steam locomotive in the United States. It runs at Strasburg during the railroad's thrice-yearly Day Out With Thomas events. (© 2017 Gullane [Thomas] Limited. Thomas the Tank Engine & Friends, Thomas & Friends, and Day Out With Thomas are trademarks of Gullane [Thomas] Limited.)

One of only a few pieces of extant equipment originally owned by the pre-1958 Strasburg Rail Road is PRR boxcar No. 96451, built in 1907 by the Pressed Steel Car Company. It was sold to the Strasburg Rail Road in 1929 and renumbered as W-04. After years of hauling freight, milk, and other goods, the car was well worn by the time this photograph was taken in September 1957. In 1992, the car was restored, and it remains on the property today.

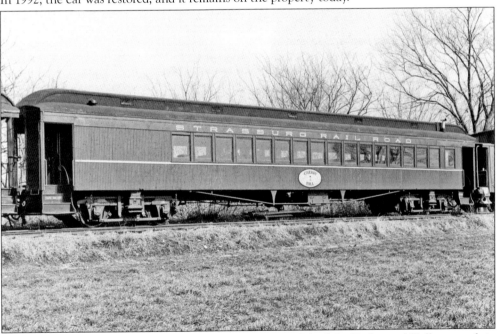

A closed-vestibule P&R class PBf composite passenger coach built by Harlan and Hollingsworth in June 1911 was the first passenger coach acquired under the Strasburg Rail Road's new leadership. The retired Reading Company coach arrived in Strasburg in December 1958 as a donation from the Reading Company. Numbered as SRC No. 28 (and later as SRC No. 58), this car was outfitted with a snack bar and gift counter that served as the railroad's only gift shop until 1961. This February 27, 1960, photograph by John Bowman shows the coach before the gift counter was removed.

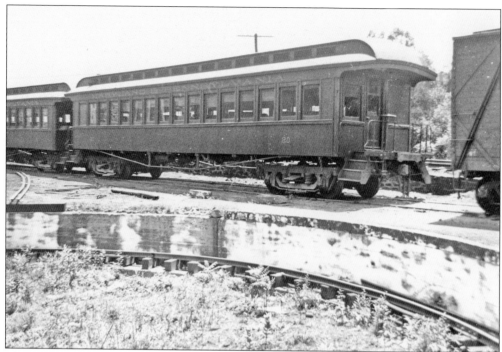

The second wooden coach car acquired by the revived Strasburg Rail Road was the ex-Maryland & Pennsylvania Railroad No. 20 non-vestibule passenger coach, built by the Jackson & Sharp Works in 1913. After spending over 40 years on the MA&PA, the car was sold in 1956 to the Baltimore chapter of the NRHS, which in turn sold it to the Strasburg Rail Road in April 1959 for $300. The car had its own brush with stardom when it appeared in the movies *Raintree County* (1956) and *Wild Wild West* (1998). This June 18, 1942, photograph by Charles Mahan Jr. shows No. 20 sitting in the MA&PA yard in Baltimore.

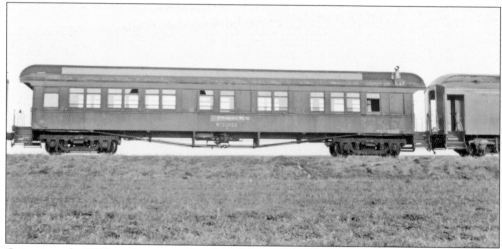

Going into the 1959 tourist season, Strasburg had expanded its passenger fleet by threefold. The third coach to be added to the Strasburg roster was ex-Boston & Maine open platform work car No. W3262, built in 1904. Boston & Maine sold the car to Don Hallock for $450 in March 1959. The car was readied and put into passenger service by the 1959 Memorial Day weekend. This photograph shows the coach arriving at Strasburg on April 18, 1959.

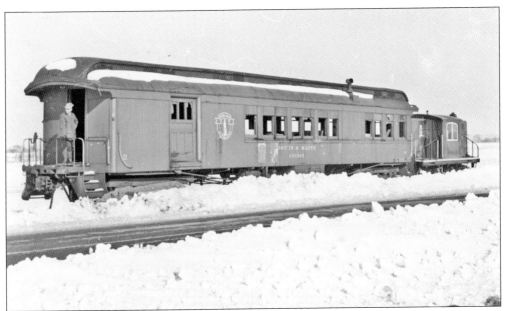

The continued astronomical rise in ridership precipitated the need for a fourth coach. This time, ex-Boston & Maine combination baggage-passenger coach No. 103502, built in 1903, was purchased for $700 through a deal facilitated by Don Hallock, for whom the car would later be named. Seen here is the combine car arriving at Strasburg on November 30, 1960. Huber Leath and Stewart Armstrong picked up the car at Leaman Place using No. 7. After it was refurbished, the car was first put into service for the 1961 season, and it is still frequently used today.

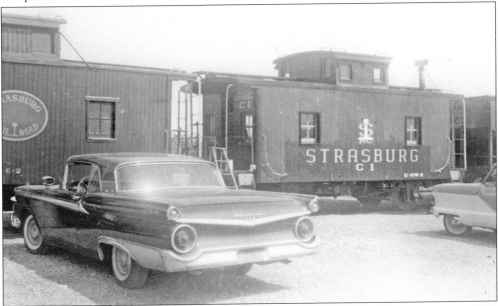

Strasburg Rail Road acquired its first caboose—the 1905 ex-PRR No. 485923—in October 1959. Thanks to Bud Swearer, a second caboose—the 1910 ex-PRR No. 486709—was acquired two months later. This photograph from December 1960 shows both of those cabooses, numbered as C-1 (later No. 10) and C-2 (later No. 11), respectively, sitting at the passenger depot. Note the two different SRC logos emblazoned on the cabooses; the company's first logo is displayed on C-1.

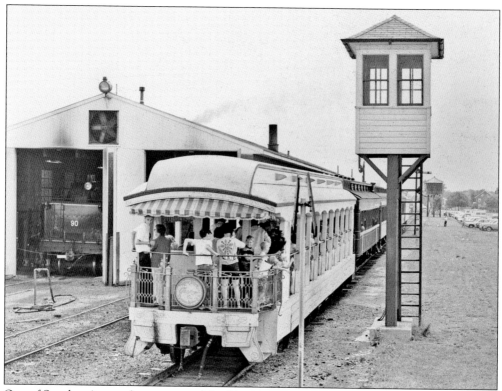

One of Strasburg's most famous cars is No. 68, an open-air observation wooden passenger coach named *Hello Dolly*, whose fame stems from its appearance in the 1969 movie of the same name. Originally built in 1896 by the Pullman Car Company, it is the oldest passenger car on Strasburg's roster. The *Hello Dolly* car is shown passing the Pennsylvania watchman's tower in this undated photograph by William Moedinger.

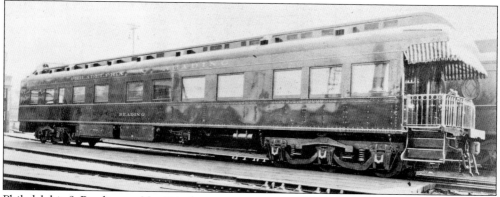

Philadelphia & Reading car No. 10 is the most luxurious and likely the most storied of all Strasburg's accommodations. Built by Harlan & Hollingsworth in 1913 specifically for the president of the Reading at a cost of nearly $56,000, the car was used by railroad and social luminaries such as George F. Baer and Edward T. Stotesbury during its first 50 years of service. The car was purchased by Strasburg Enterprises in 1964 and sat on static display for many years at the Strasburg Rail Road. It was fully restored and put back into passenger operations in 2002. P&R No. 10's Reading green livery gleams in this c. 1920s photograph. (General Negative Collection, Railroad Museum of Pennsylvania, PHMC.)

Four

STRASBURG BUILDS A STATION, SHOPS, AND STORES

In an effort to provide a railroading experience reflective of the early 20th century, the Strasburg Rail Road Company strategically planned to replicate an early street/station scene surrounding the passenger depot after the depot moved to the east of the Route 741 crossing.

When tourist operations began at the Strasburg Rail Road in late 1958, the 24 investors continued to use the Homsher Mill as the passenger and freight depot as it had been used since 1852. However, with the burgeoning tourist market bringing increased numbers of riders day after day, it was quickly determined that a much larger depot was needed.

In May 1960, the passenger depot moved just east of the Route 741 crossing when Reading Railroad's former East Petersburg Station found a new home—and a new name—in Strasburg. The newly named East Strasburg Station, a Frank Furness–designed 1882 railroad depot, became the hub for all passenger operations, which grew exponentially when steam motive power was reintroduced.

With steam's return to Strasburg's line in 1960, the diminutive engine house that housed the 1926 gasoline-powered Plymouth No. 1 proved to be too small for the 0-6-0 Canadian National locomotive. Therefore, after passenger operations moved in the spring of 1960, so did mechanical operations. A two-bay engine house was built shortly thereafter to accommodate the growing operation.

Along with an exponential increase in passengers came a desire from guests for souvenirs and food. In response, a modest stand-alone gift shop and a small restaurant were built on the property.

Through the years, the property has undergone several expansions and redesigns, but all have remained true to the company's mission. Today, the passenger station area is anchored by the East Strasburg Station in the middle with the former PRR LEMO (Lemoyne) interlocking tower on the west and the company's mechanical and car shops on the east, now with three gift shops, an expanded café, a crew house, various offices, a freight yard, and several child-oriented activities in between.

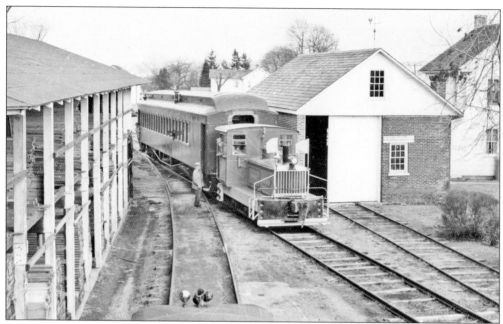

Strasburg Rail Road's first engine house is seen on the right as William Moedinger brings in Plymouth No. 1 in the spring of 1959. Strasburg's main track ran beside the engine house and down the middle of the Homsher Mill lumberyard. The sign above the window on the engine house reads "Freight Office, Strasburg Rail Road."

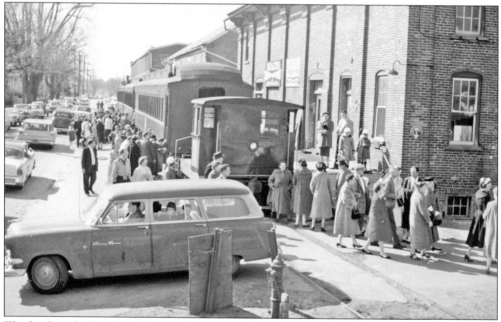

The loading dock at the 1860s-era former Homsher Mill complex served as the Strasburg Rail Road's passenger depot for the first 17 months of tourist operations. Shown here is a crowded passenger depot during the 1959 Christmas season. The sign between the fire hydrant and the Ford Country Squire station wagon advertises the Santa Special. (Huber Leath Collection, Railroad Museum of Pennsylvania, PHMC.)

Even when tourist operations began, the owners knew that the Homsher Mill would be insufficient to hold the number of riders if and when steam motive power was reintroduced at Strasburg. So when the SRC learned of the impending removal of the Reading Company's former East Petersburg Station, the SRC executives jumped at the chance to have that historic building as the centerpiece for their railroad. Shown here in April 1960 is the pad site (purchased from the Shaubach estate) for the future East Strasburg Station. (Lynford Swearer Collection, Railroad Museum of Pennsylvania, PHMC.)

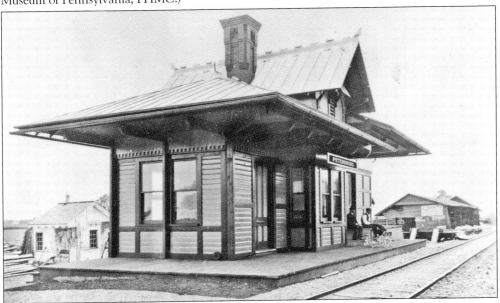

The former East Petersburg Station along the Reading Railroad's Lancaster Branch is seen in this c. 1890 photograph. The building was designed and built by a famed railroad architect from Philadelphia, Frank Furness, in 1882. Two men sit on the baggage platform waiting for the next train to arrive. (John Denny Collection, LancasterHistory.org)

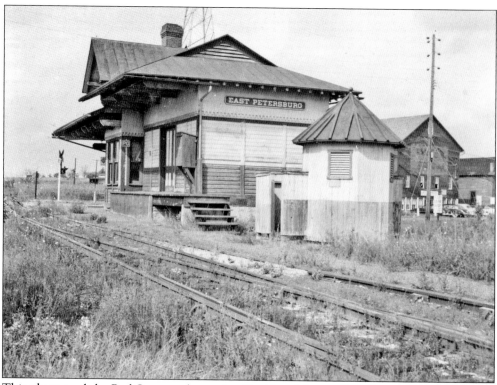

This photograph by Bud Swearer shows the dilapidated former East Petersburg Station with accompanying outhouse (the adjacent octagonal shaped building) just days before the building was dismantled and moved to Strasburg on April 30, 1960. Notice the telephone call box at the edge of the baggage platform.

NOTICE

NOTICE is hereby given that effective April 5, 1960, Reading Company will change the status of its station at East Petersburg, in East Hempfield Township, Lancaster County, Pennsylvania, from that of an agency freight station to that of a non-agency freight station pursuant to order and certificate of Public Convenience entered by the Pennsylvania Public Utility Commission, February 23, 1960. Docket No. A. 86774.

Posted this 9ᵗʰ day

of March , 1960.

E.E. ____, Jr.

Ass't Div'n Agt + Op'r

(Title)

A. N. Jewell, General Manager
Reading Company, Outer Station
Reading, Penna.

"Notice is hereby given that effective April 5, 1960, Reading Company will change the status of its station at East Petersburg . . . from that of an agency freight station to that of a non-agency freight station" reads the notice posted on the station door on March 9, 1960. This notice prompted the SRC to pursue the building's purchase.

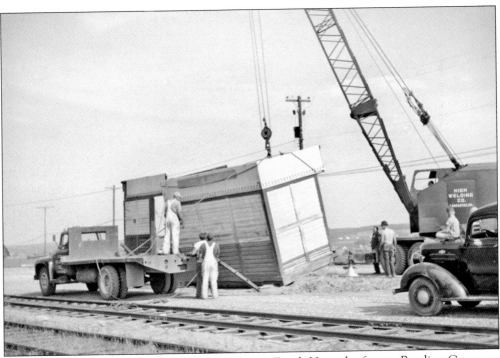

Under the supervision of SRC's master carpenter, Frank Herr, the former Reading Company station was disassembled in nine sections—three base and six roof—and placed on a flatbed truck from High Steel. According to legend, the truck got lost en route to Strasburg and showed up two hours later than scheduled. This photograph shows the first section of the station being raised at its new home. (Huber Leath Collection, Railroad Museum of Pennsylvania, PHMC.)

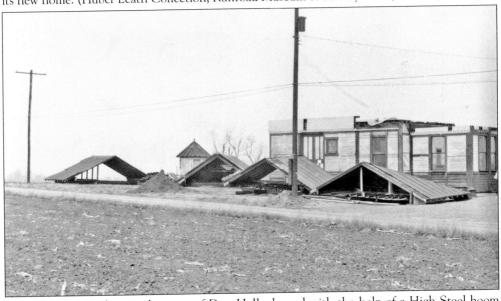

With the close and meticulous eye of Don Hallock, and with the help of a High Steel boom crane, the station building was reassembled in just hours on April 30, 1960. This Bud Swearer photograph shows the future East Strasburg Station just before the last of the roof sections was raised into place.

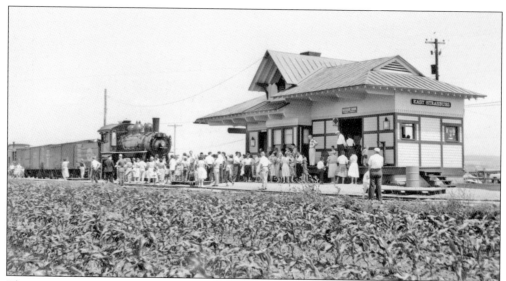

The new East Strasburg Station—the new terminal for all of Strasburg Rail Road's passenger operations—opened on May 15, 1960, just in time for the busy 1960 Memorial Day weekend. Seen here is the new station on one of its first days of operations at Strasburg in May 1960. Notice the newly arrived ex-CNR No. 7312 sitting on static display next to the station. Within four months, it also would be back in operation.

Until 1964, the parking lot at the Strasburg Rail Road was the barren dirt area between the station and the new engine house at the east end of the property. The area accommodated about 150 cars. In this summer 1960 photograph, the parking lot is full, as hundreds, if not thousands, of people visited that day to ride "the Road to Paradise." (Huber Leath Collection, Railroad Museum of Pennsylvania, PHMC.)

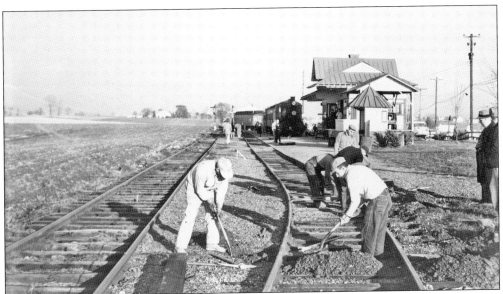

SRC vice presidents Max Solomon (in long overcoat) and Huber Leath (to Solomon's left) watch as workers shore up some weak spots in the siding track adjacent to the main track in this November 1960 photograph by Bud Swearer. With the introduction of steam, the company quickly realized that the rails were adequate for a 20-ton gasoline locomotive but not for a 76-ton steam locomotive. (Lynford Swearer Collection, Railroad Museum of Pennsylvania, PHMC.)

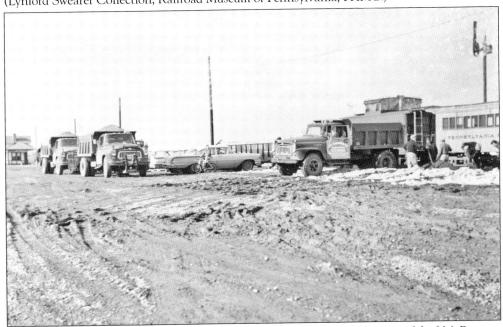

SRC vice president and director Lee E. Brenner was also president and owner of the J.M. Brenner Company, a stone and quarry company on the Sunnyside peninsula in Lancaster City. The Brenner Company supplied ballast for Strasburg's track improvement for most of the early years of tourist operations. This December 1960 photograph shows a muddy parking area while the track receives new ballast. Notice the c. 1855 Cumberland Valley Railroad (CVRR) Combine B car coupled to a PRR caboose.

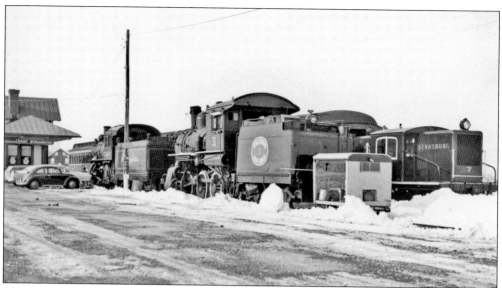

This view of the station area from December 1960 shows some of SRC's most unusual motive power from the early years of operation after a recent snowfall. Notice the four-cylinder track car that was used heavily during 1958 and 1959, recently purchased 0-6-0 No. 31, the leased 4-4-0 No. 1223, and the recently refurbished No. 7, along with several wooden coach cars.

The increased and expanded motive power precipitated the urgent need for a bigger and better engine house to replace the diminutive structure that stood at the tracks' western terminus. Construction began on SRC's existing engine house in October 1960, just a few months after the station building was moved to Strasburg. SRC's boxcar W-04 sits in front of the under-construction building as a boom crane lifts a roof rafter. (Huber Leath Collection, Railroad Museum of Pennsylvania, PHMC.)

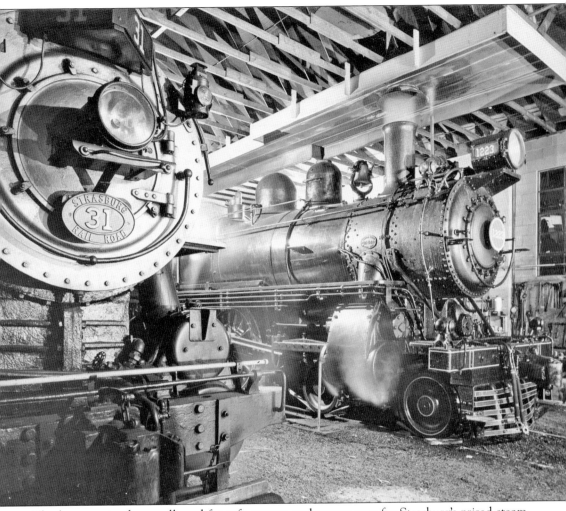

The large engine house allowed for safe storage and proper care for Strasburg's prized steam locomotives, including No. 31 and No. 1223, as seen in this Gordon Roth photograph. (Courtesy of Linn Moedinger.)

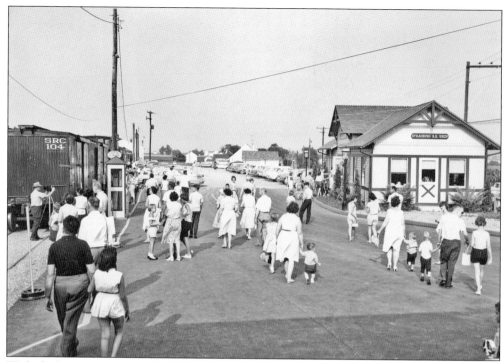

With the burgeoning visitation, the snack bar and gift counter on coach car No. 28 had become outgrown. In 1961, William and Marian Moedinger built a stand-alone gift shop to accommodate visitors' desires for a souvenir of the historic railroad. The Strasburg gift shop was one of the first stand-alone gift shops at a tourist attraction in Lancaster County.

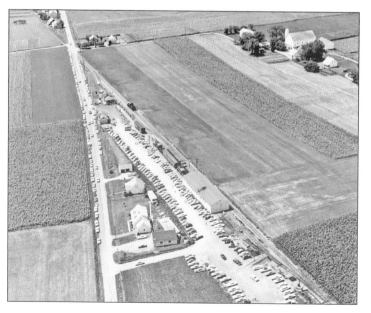

The Strasburg Rail Road had come a long way since its 1958 rejuvenation by the time Jim Hess took this aerial photograph in 1962. The station building, the engine house, the gift shop, and other preexisting ancillary buildings are seen on the company's property. Once the parking lot was full, patrons made their own overflow parking along Route 741's shoulder, much to the consternation of the Pennsylvania State Police.

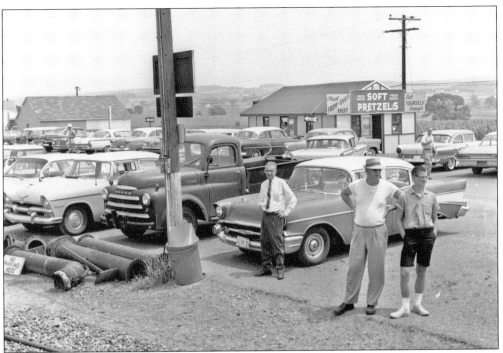

Like today, many secondary businesses fed off of the railroad's popularity. This was the case in the summer of 1963, when Don Dorwart opened a pretzel stand in a wedge of land he owned that bordered the railroad's parking lot. The "Coney Island" feel of the stand put Dorwart at odds with the railroad, which wanted to maintain an authentic historic experience. Eventually, the railroad bought Dorwart's land, and the soft pretzel stand controversy was history. (Lynford Swearer Collection, Railroad Museum of Pennsylvania, PHMC.)

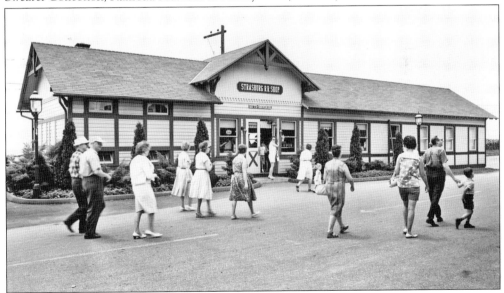

The Strasburg Rail Road's gift shop, owned and operated by William and Marian Moedinger, boasted railroad books, souvenirs, and other railroad-related items. Popularity and continued strong visitation prompted the building's expansion in the mid-1960s.

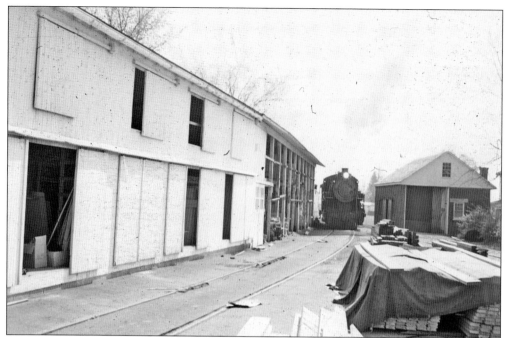

Ex-GW 2-10-0 No. 90 traverses the rails to the I.B. Graybill Mill at the historic western terminus of the railroad on August 31, 1968, to deliver three boxcars to the lumber mill. Little had physically changed at the mill in the 10 years since the Homsher Estate sold the railroad. (Ellis Bachman Collection, Railroad Museum of Pennsylvania, PHMC.)

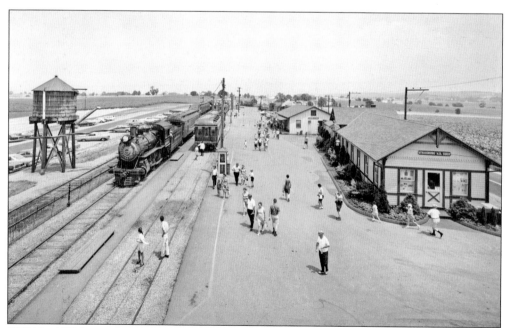

PRR No. 1223 brings its consist into the passenger depot in this c. 1967 photograph. The "Paradise" car (P&R No. 10) sits on static display to allow people to wander through at their leisure. The railroad's mechanical and car shops were not yet built when this photograph was taken.

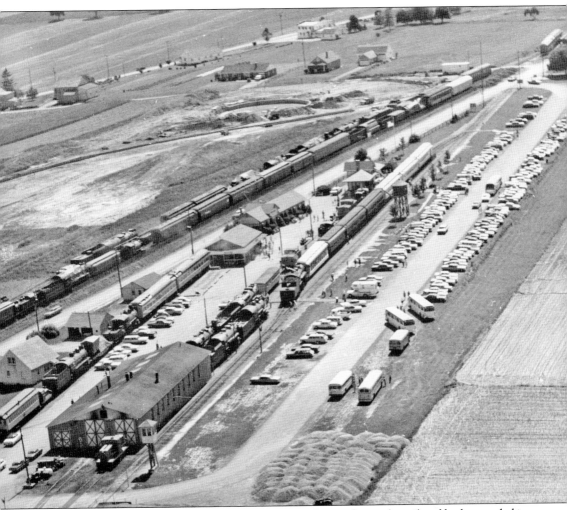

By 1970—less than 10 years since the aerial view on p. 90 was taken—the railroad had expanded its footprint to include a 450-car parking lot, an eatery, a larger engine house, a car shop, and hundreds more feet of track. Various pieces of SRC equipment, plus the Pennsylvania's historical collection at the future site of the museum, are seen in this summer 1970 photograph by Henry DeWolf.

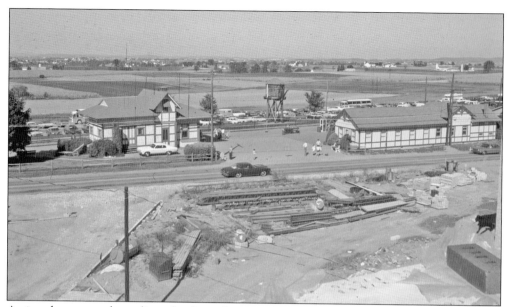

A view that cannot be replicated today is this vista from about 1973 showing the station and gift shop areas from atop the future Railroad Museum of Pennsylvania, then nearing completion. The wooden water tank stands at center. The flat, meandering countryside for which Lancaster County is known is seen in the distance. (Ellis Bachman Collection, Railroad Museum of Pennsylvania, PHMC.)

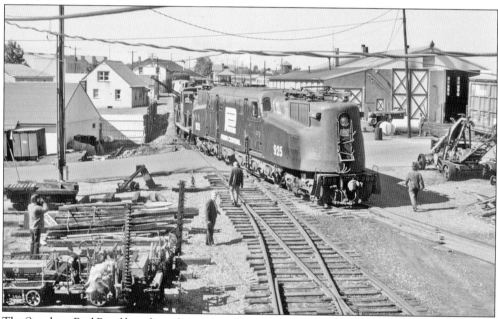

The Strasburg Rail Road has always been more than just a tourist railroad; in fact, it has been a tale of two businesses—one tourist and the other mechanical and contract work—both of which the railroad has become the "gold standard" for. The SRC has always been a working railroad, as evidenced by this October 8, 1974, photograph of Penn Central's GG-1 No. 925 coming in for mechanical work. The power lines and telephone lines create an overhead canopy typical of 20th-century industrial America. (Ellis Bachman Collection, Railroad Museum of Pennsylvania, PHMC.)

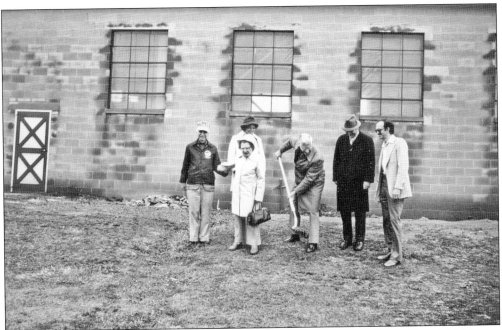

On March 19, 1983, (from left to right) Winston Gottschalk, Nancy Long Gingrich, Marian Moedinger, William Moedinger, Huber Leath, and Henry Long Jr. break ground for the new Don Hallock–designed 8,500-square-foot mechanical shop, which would enable the SRC to maintain and overhaul its fleet of steam locomotives.

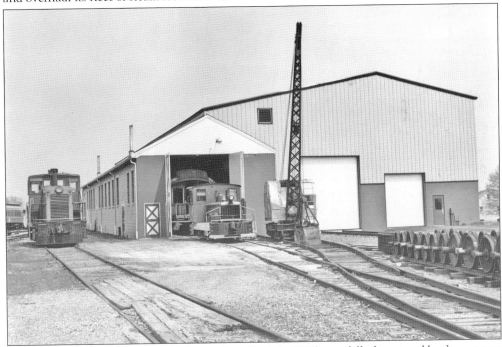

The mechanical shop, adjacent to the car shop (built in 1968), was fully functional by the summer of 1984. In this c. 1985 photograph, old standby Plymouth No. 1 appears to be coming out of the car shop while SRC No. 33 waits on the RIP track.

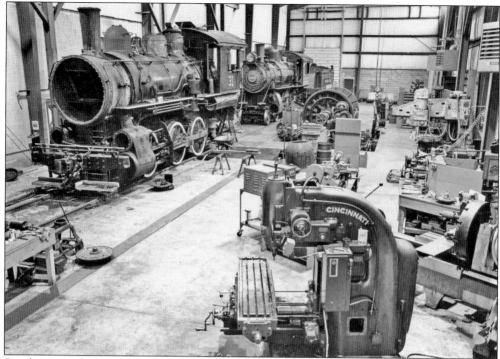

Strasburg's mechanical shop boasts a myriad of equipment designed for the repair and maintenance of steam locomotives. The SRC mechanical shops are considered one of the best steam locomotive repair shops in the world. SRC is still the go-to company for a plethora of world-renowned organizations when work is required on their equipment. Seen here are No. 31 and No. 1223 in for their annual work around 1984. As of this writing, SRC plans to expand the shop by 18,000 square feet to meet the increased demand for contract work.

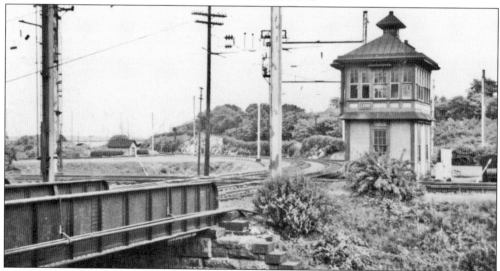

In 1984, the local chapter of the NRHS acquired the Pennsylvania's former LEMO interlocking tower and moved it to the Strasburg Rail Road. The c. 1885 structure, originally named J Tower, sat continuously at the Lemoyne, Pennsylvania, junction until its removal by the NRHS. The LEMO tower is seen at Lemoyne in this undated photograph.

The continued rise in ridership demanded that the railroad continue to expand its retail space. In late 1988, gift shop co-owner and manager Susan Moedinger expanded the newer of the two gift shops. In 2011, after outgrowing the former Don Dorwart home—just to the east of this building—which the company had used as a business office since 1971, the upper floor of this building became the Strasburg Rail Road's new business office after it purchased the gift shop buildings from the Moedingers. (Courtesy of Linn Moedinger.)

On June 29, 1989, the Strasburg Rail Road debuted its Strasburg Showcase Theater, constructed by Ned Viars. The building boasted a 150-seat theater, a diorama, a scale-model replica of the town of Strasburg from 1900, and a model train exhibit. However, with a change in generational tastes and with the advent of Thomas the Tank Engine, the museum and theater disbanded, and in its place eventually came one of Lancaster County's only gift shops dedicated to Thomas the Tank Engine merchandise.

The Strasburg Rail Road has come a long way since its humble rebirth in 1958. This summer 2015 aerial photograph shows the bustling freight yard, ever-growing car and mechanical shops, historic station, and mall areas, all surrounded by picturesque Amish farmland. Visitors to the Strasburg Rail Road can often see more train activity at this historic railroad than at some major train depots. The SRC continues to maintain both an active freight and passenger service, as it did in the 1850s.

Five

SPECIAL EVENTS AND HAPPENINGS AT STRASBURG

Special events at the Strasburg Rail Road have always played a significant role in passenger operations since 1958. Recurring events at the railroad, from the classic Santa's Paradise Express or the Easter Bunny Special to the unique offerings of Steampunk unLimited, Vintage Baseball Day, and others, help undergird Strasburg's mission to offer a unique and new experience to its passengers every time they visit the railroad.

Similarly, special events encompass those one-time occurrences precipitated by Strasburg's inherent uniqueness. The Strasburg Rail Road has been featured in a variety of media—film, motion, print, and digital—to varying degrees to promote products, unveil new initiatives, restore historic equipment, or simply record the site of a steam locomotive rolling through bucolic Amish Country. Those special one-time events help promote the Strasburg Rail Road to the broader community and contribute to the growth of not only the Strasburg Rail Road but to Lancaster County's tourism economy.

In the fall of 1959, the former Slaymaker Lock Company, the country's largest manufacturer of railroad and railroad-related padlocks, produced its five millionth heavy-duty railroad switch lock. To commemorate the event, two gold-plated switch locks were made. This Lancaster Newspapers photograph shows W. Heyward Smith (center), vice president of Lancaster-headquartered Slaymaker Lock, presenting one gold lock to Henry K. Long (left) of the SRC and the other to Al Kalmbach (right) of Milwaukee, Wisconsin, publisher of *The Model Railroader* and *Trains* magazine. (Courtesy of LNP Media Group Inc.)

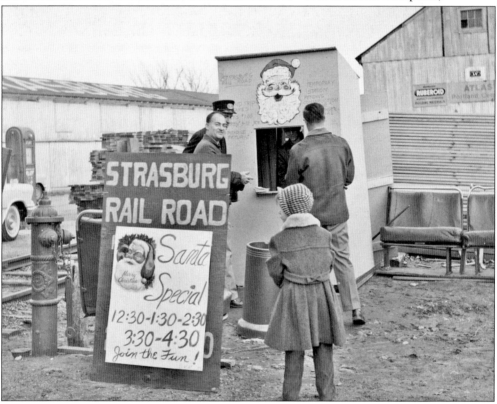

Strasburg Rail Road's Santa's Paradise Express has been a passenger favorite ever since the first event in December 1959. SRC's temporary ticket booth, made out of plywood, is seen in this photograph by Bud Swearer. Note the wording to the right of Santa's head, "Temporary station pending construction of our new passenger terminal." Also note the bus seats serving as the makeshift waiting room. Santa's Paradise Express is still one of the railroad's biggest events even after six decades. (Lynford Swearer Collection, Railroad Museum of Pennsylvania, PHMC.)

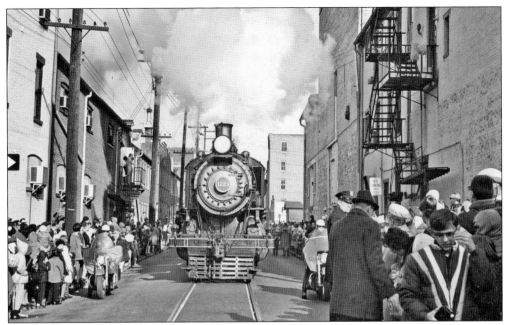

Santa Claus always visited Lancaster City's famed Watt & Shand department store the Saturday before Thanksgiving. All year long, children of all ages anticipated Santa's annual return. Between 1965 and 1968, Strasburg provided the motive power for Santa's trip to downtown Lancaster. These two photographs, taken by Fred Schneider and Bud Swearer, respectively, on November 20, 1965, show No. 1223 traveling southbound on the Quarryville branch of the Pennsylvania, whose tracks ran down the center of North Water Street. After disembarking from the train at the Water Street Station, Santa rode up West King Street, then ascended a Lancaster City ladder fire truck to the third floor of the Watt & Shand Department Store to greet the thousands of kids who came to see him that day. (Below, Lynford Swearer Collection, Railroad Museum of Pennsylvania, PHMC.)

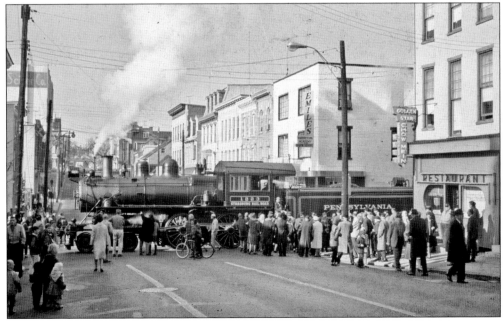

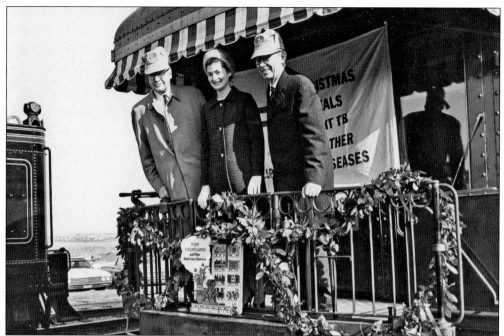

From left to right, Alan Greenough, president of the PRR; Doris Ann Lausch, Lancaster County native and Miss Pennsylvania 1967; and Davitt S. Bell, president of the Christmas Seals, pose on the observation platform of P&R No. 10. Christmas Seals used the Strasburg Rail Road to unveil its 1967 train-themed fundraising campaign. No. 1223's tender is seen to the left. It was Alan Greenough who gave the green light for No. 1223 to return to operation.

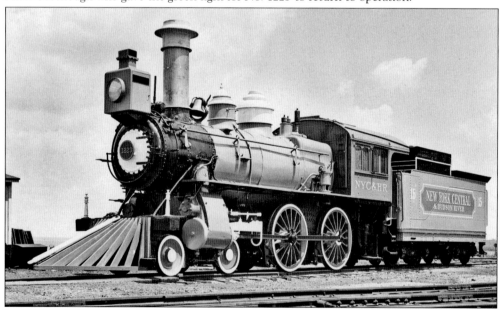

In 1968, 20th Century Fox asked Strasburg Rail Road to provide a steam locomotive and wooden passenger cars for a movie adaptation of the Broadway hit *Hello, Dolly!* Shown here is No. 1223 in outlandish grease paint depicting an 1890s livery with box headlight, oversized cowcatcher, and extended smokestack. (Lynford Swearer Collection, Railroad Museum of Pennsylvania, PHMC.)

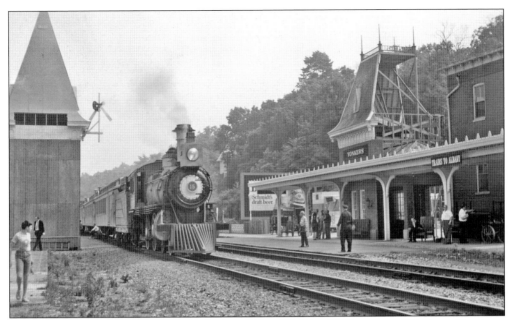

"New York Central & Hudson River Railroad No. 15" (No. 1223) comes rolling into Garrison, New York's New York Central depot, which had been transformed into the Yonkers train station in the 1890s. The notoriety the Strasburg Rail Road received from the movie helped propel ridership even more in the late 1960s and early 1970s. (Huber Leath Collection, Railroad Museum of Pennsylvania, PHMC.)

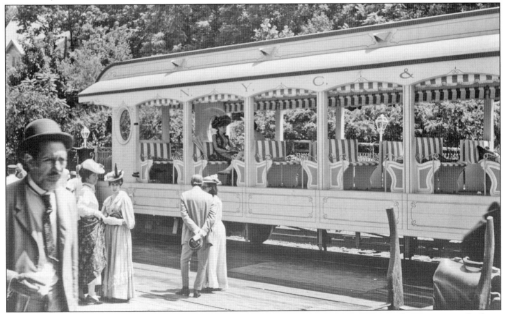

An 1896 Boston & Maine coach was rebuilt to 20th Century Fox's specifications, including extra-wide aisles and fold-down steps to allow the actors to climb aboard. Seen here is the movie's main personality, Barbra Streisand, sitting on the car as she converses between filming. The car, despite being repainted and rebuilt to Strasburg's needs, remains one of the most popular cars of the SRC fleet. (Huber Leath Collection, Railroad Museum of Pennsylvania, PHMC.)

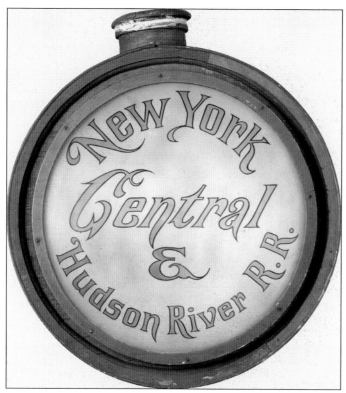

The famous NYC&HR drumhead was displayed on the observation car's rear platform, which was prominently seen when the four main characters in the movie sang and waved to the crowd in an overhead shot as they supposedly left for New York City. Made of wood and glass, the drumhead was specifically designed for the car with special mounting brackets.

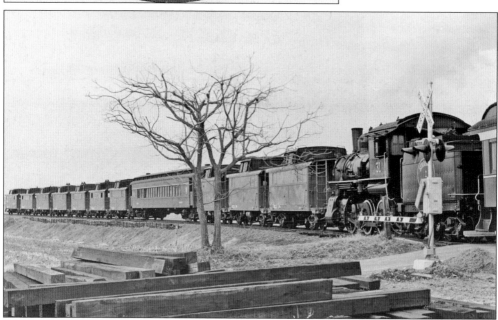

On the blustery, cold morning of February 27, 1970, SRC No. 31 pushed in 19 N-5 cabooses and a PRR P70 coach car destined for the future Red Caboose Motel. Local businessman and entrepreneur Don Denlinger envisioned and developed the Red Caboose Motel after learning that his laughable bid for 500 tons of cabooses (about $100 for each caboose) was the only bid that the entire fleet received.

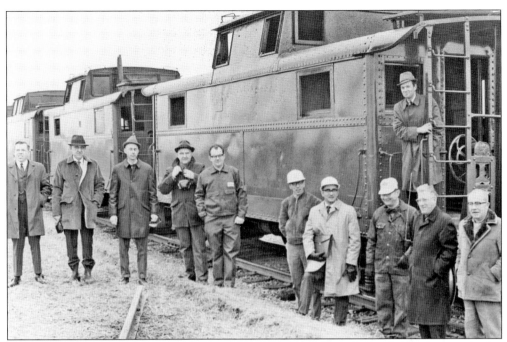

Don Denlinger (standing on caboose) poses with SRC and Penn Central officials for a photograph after some tense moments maneuvering his cabooses into their final placement at his new business.

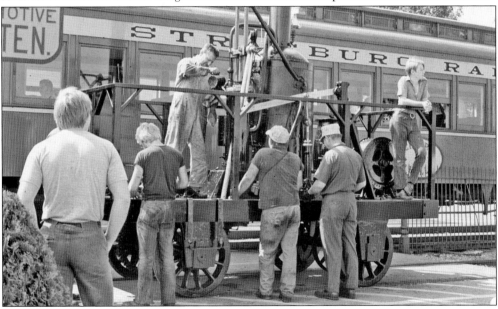

Built in 1830, the *Tom Thumb* locomotive was the first American steam engine to operate on a common-carrier railroad in the United States. Because it was not built for revenue service, its preservation was not paramount; therefore, the original was scrapped. However, in 1927, the Baltimore & Ohio Railroad (B&O) constructed a replica *Tom Thumb*. In August 1974, Strasburg Rail Road performed much of the restoration and refurbishment on the replica, which remains on display at the B&O Museum in Baltimore. (Ellis Bachman Collection, Railroad Museum of Pennsylvania, PHMC.)

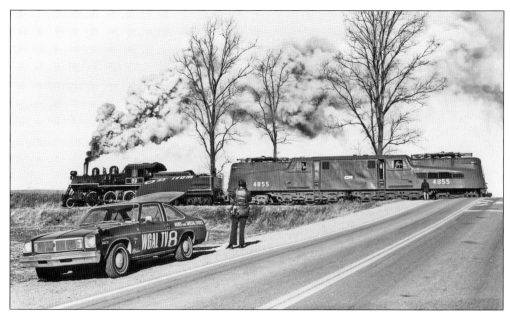

In December 1976, Conrail No. 4855 was hauling a train near Leaman Place Junction when it burned out a lead truck journal bearing. Strasburg Rail Road was quickly dispatched to make the repair. No. 89 is seen here towing the GG-1 across Carpenter's Crossing. Huber Leath and Linn Moedinger are in No. 89's cab, while local NBC-affiliate WGAL-TV was on hand in its 1976 Oldsmobile Omega to film the unusual sight.

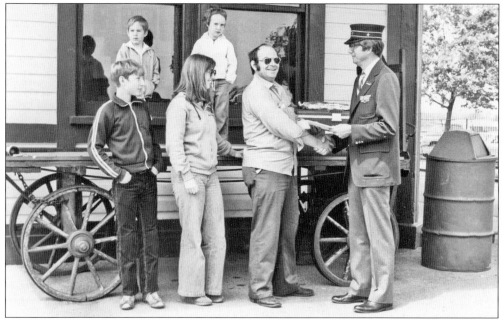

On May 17, 1980, Strasburg Rail Road welcomed its five-millionth passenger. Myron Jerscheid of Baltimore was pleasantly surprised to learn of his unique honor when he purchased his tickets at the station. SRC vice president Ellis Bachman was on hand to congratulate Jerscheid, as seen in this photograph. Along with Jerscheid are Fred and Charlotte Somerloch (behind Jerscheid). Kevin and Kerri Lynn Jerscheid stand on the baggage cart.

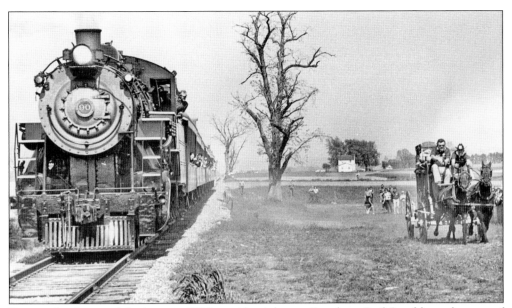

During the throes of the historic 1980 presidential race, Strasburg Rail Road hosted a race of another kind. To celebrate the 150th anniversary of the "Great Train Race," a reenactment took place on May 10, 1980, as the iron horse competed against the real thing. No. 90 and a historic stage coach, bought and provided by Don Denlinger, race for the finish line in this Lancaster Newspapers photograph. In the end, the iron horse always wins. Fireman Stephen Weaver (now vice president of roadway) is seen leaning out of the cab. (Courtesy of LNP Media Group Inc.)

Drew Lewis (left), Reading Company trustee, 1974 Pennsylvania gubernatorial candidate, secretary of transportation under Pres. Ronald Reagan, and later president and chief executive officer of Union Pacific, visited the Strasburg Rail Road on January 22, 1982. Lewis is posing with SRC founder William M. Moedinger.

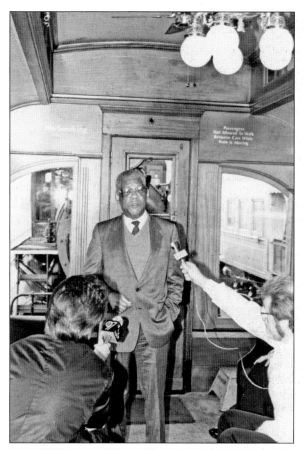

Pennsylvania house speaker K. Leroy Irvis, the first African American elected speaker of the house in any state legislature since the Civil War, takes questions from the media while standing on the recently unveiled first-class parlor car in this November 1988 photograph.

Strasburg Rail Road

Shareholders Inspection Trip
150th Anniversary Celebration
SATURDAY, JUNE 5, 1982
The Strasburg Limited 3:55 P.M.

The Strasburg Rail Road celebrated its 150th anniversary on June 9, 1982. On the preceding Saturday (June 5), SRC shareholders were treated to a historic "inspection trip" at 4:00 p.m. Each shareholder was given a commemorative gold pass for that trip. Seen here is one of those rare passes.

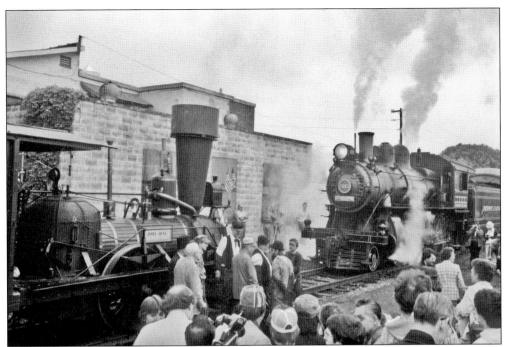

On May 22, 1983, the *John Bull* replica made its first public appearance after its restoration. During a brief stop at Leaman Place, at which it met up with PRR No. 1223, the two centuries of steam locomotion drew significant attention. From left to right, SRC's Kelly Anderson, Bill Withuhn, Huber Leath, Ben Kline, Linn Moedinger, and Jim Rice huddle around the antique apparatus. (Ellis Bachman Collection, Railroad Museum of Pennsylvania, PHMC.)

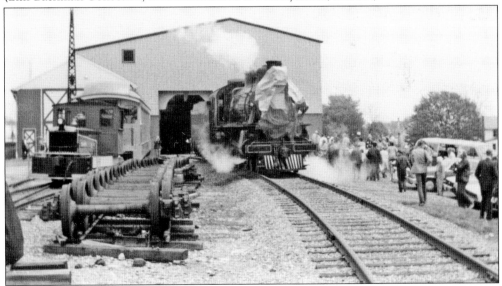

In a ribbon-cutting ceremony befitting a historic steam railroad, PRR No. 7002 breaks through a giant ribbon, thus officially opening Strasburg Rail Road's new back shop in the spring of 1984. The additional 8,500 square feet gave the SRC a better and more efficient space to maintain its fleet of steam locomotives. It also helped better equip the SRC to repair and restore the assets of countless other heritage railroads and museums.

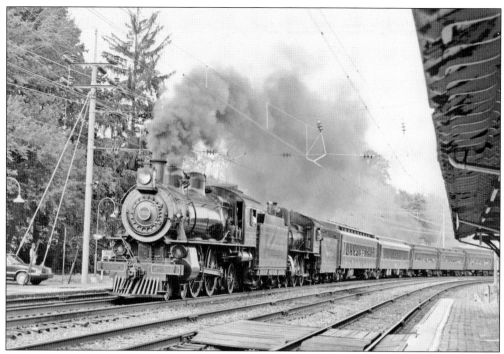

A doubleheader excursion trip with 10 coaches pulled by both Pennsylvania locomotives—No. 1223 and No. 7002—leaves Leaman Place for Philadelphia on May 18, 1986. In this William Moedinger photograph, the excursion is heading west through Berwyn Station. (Courtesy of Linn Moedinger.)

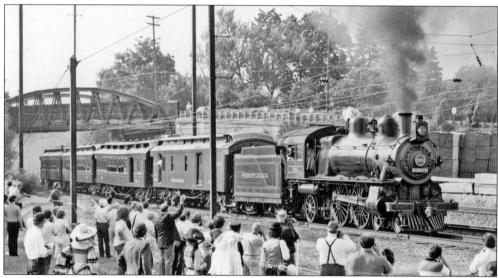

In 1987, the *Broadway Limited*, a PRR passenger train running between New York City and Chicago, celebrated its 75th anniversary. To commemorate the milestone, Strasburg's PRR No. 7002 with an all-PRR consist is positioned to rendezvous with the modern *Broadway Limited* at Leaman Place on June 14, 1987. Note the period fashions of several onlookers. Commemorative gifts and pleasantries were exchanged between the two crews before both trains went on their respective ways.

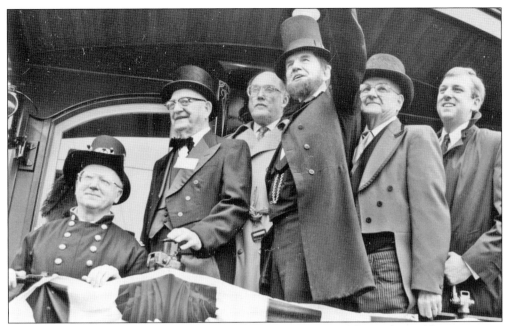

The historic town of Gettysburg rolled out the red carpet to celebrate the 125th anniversary of Abraham Lincoln's 1863 address. On November 19, 1988, Strasburg's No. 7002 and three coaches—including the newly christened first-class parlor car—helped deliver dignitaries to Gettysburg. This photograph shows James Getty (as Lincoln) alongside Chief Justice William Rehnquist (center, in trench coat) and Pennsylvania lieutenant governor Mark Singel (far right) standing on the rear platform of SRC's parlor car.

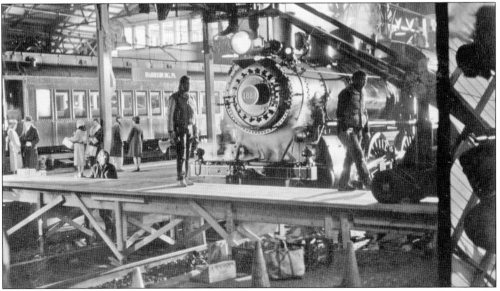

Prudential Insurance Company used both of Strasburg's PRR locomotives during filming of a period television commercial in January 1989 at Harrisburg's Amtrak Station. No. 1223 patiently sits during rehearsal at the bustling depot. It is interesting that this marked the last major event at which both locomotives appeared together. In fact, this was the last trip under steam for No. 7002. By the end of the year, both iconic locomotives were retired.

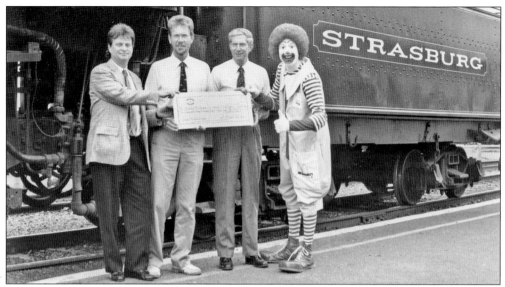

SRC president Fred Bartels (1988–2000), center left, and Ellis Bachman, center right, present a check to the Ronald McDonald House's Stephen J. Arnold (left) and Ronald McDonald in this 1990 photograph. The donation was given to the Ronald McDonald Children's Charities of Central Pennsylvania.

In August 1992, Pennsylvania governor Robert Casey visited the Railroad Museum of Pennsylvania to release $1.6 million in state funding for the museum to expand its rolling stock hall addition. After the brief bill-signing ceremony, the governor and his entourage, including his budget secretary and state representative Jere Schuler, walked across the street and were treated to a private charter on SRC's first-class accommodations. Here, Governor Casey is talking with constituents before boarding the train.

Six

PASSENGERS, PATRONS, AND STAFF

Employees are the most valuable asset of any organization. Through the first 60 years, a plethora of invaluable employees—engineers, conductors, brakemen, ticket agents, red caps, machinists, carpenters, and more—have worked at Strasburg Rail Road. They helped build and continue to help make Strasburg Rail Road the gold standard of tourist railroads. The employees and staff of the historic Strasburg Rail Road readied this tiny railroad for the 21st century, continuing a century-and-a-half-old tradition of operating a world-class steam train excursion, providing quality repair and restoration for railroads across the country, and supporting the local community through an active freight service.

It is impossible to single out every one of the hundreds of dedicated individuals who worked at Strasburg over the decades. No doubt there are many, many individuals who should belong in this chapter, but with limited space and lack of images, it is impossible to include them here. This chapter is a small sampling of a few key individuals who played various roles in the railroad's development before 1980. The lack of images or specific mention of many other individuals during that timeframe certainly does not diminish their extraordinary contributions to the Strasburg Rail Road.

In addition, some of the following photographs depict the important role of the SRC's passengers through the years. Without passionate fans, returning visitors, and the constant influx of new passengers, the Strasburg Rail Road would not be what it is today.

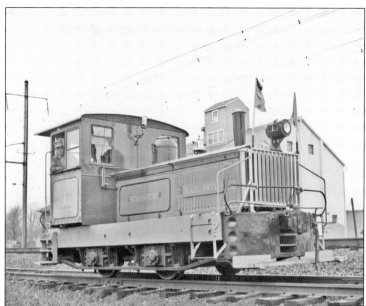

The venerable William M. Moedinger Jr., one of the original 24 investors in 1958 and president of the Strasburg Rail Road from 1971 to 1987, sits in the cab of Plymouth No. 1 while performing the drop at Leaman Place Junction in this 1959 photograph.

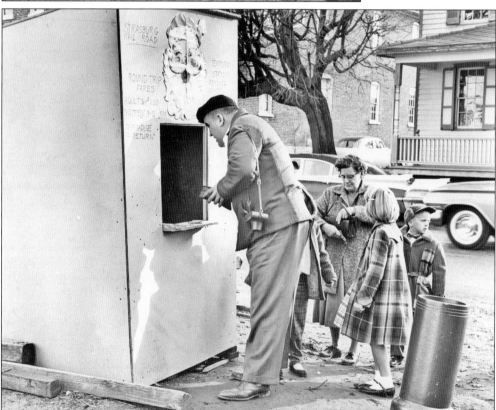

In this December 1959 photograph, a man bedecked with wingtips and dress pants and sporting a 35-millimeter camera stands in the mud directly in front of Strasburg Rail Road's first ticket booth. He eagerly purchased tickets for himself and his family to ride the railroad's first "Santa's Special."

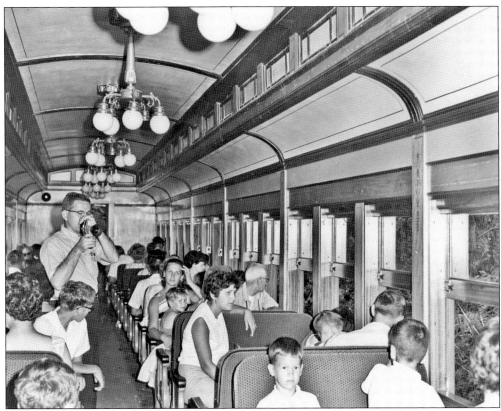

A passenger stands in the middle of a full coach car using his 8-millimeter movie camera to film his Strasburg Rail Road experience as his family looks out the window at the passing Lancaster County countryside in this undated photograph. The passengers are riding in Strasburg's ex-Reading Company coach car, currently numbered as SRC No. 58.

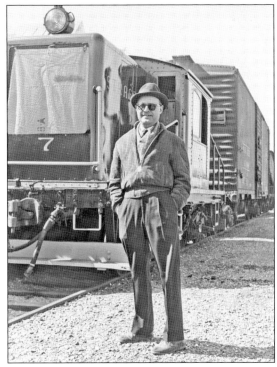

Henry Keiper Long, president of the Lancaster Champion Blower & Forge Company and president of the Strasburg Rail Road Company (1958–1963), stands in front of SRC No. 7 in this c. 1961 photograph. Henry Long was one of the individuals who spearheaded the effort to revive and restore the Strasburg Rail Road beginning in 1958.

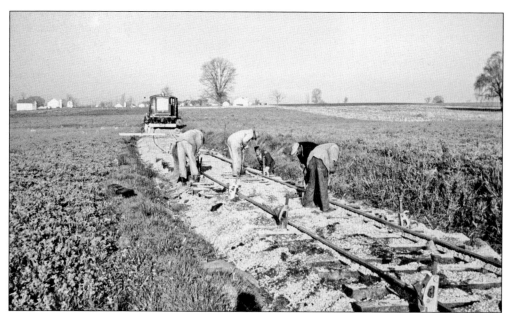

In the weeks after steam returned to Strasburg, the directors quickly realized that their track did not meet the standards for a rigid wheelbase steam locomotive; the locomotive was tearing up the track. They needed new ties, heavier rails, new splice bars, and a better foundation of stone ballast. On October 26, 1960, temporary workers and volunteers perform maintenance-of-way work just east of the Fairview Crossing as SRC No. 7, a 1915 General Electric locomotive, sits in the distance. (Huber Leath Collection, Railroad Museum of Pennsylvania, PHMC.)

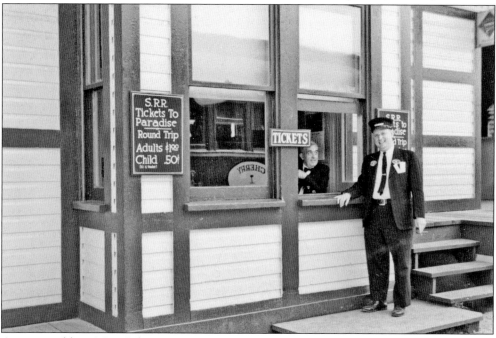

A cigar-wielding Max Solomon II, PRR executive and an original SRC investor and vice president, chats with Les Myers at the East Strasburg Station between passenger runs to Paradise, Pennsylvania.

Jan Deelman, another of Strasburg's first vice presidents and original investors, grins from ear to ear as he waits for the passenger train to return to the East Strasburg Station in the fall of 1960.

In this mid-1960s photograph by William Moedinger, longtime ticket agent Joe Gonder sells tickets from the historic East Strasburg Station, which has served as the hub for passenger operations since May 1960. Gonder and his fellow ticket agents sold thousands of tickets each week to new and returning passengers who wanted to ride the "Road to Paradise." (Courtesy of Linn Moedinger.)

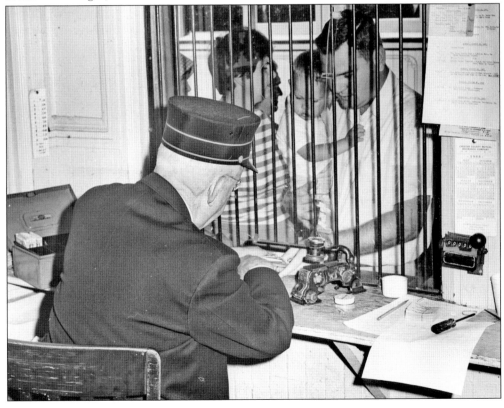

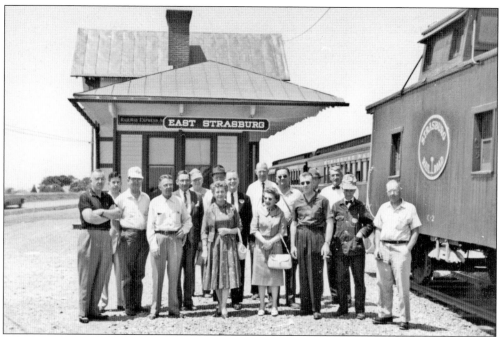

On June 11, 1960, the board of directors of the Strasburg Rail Road Company poses in front of the recently relocated East Petersburg (now East Strasburg) Station. From left to right are George Ellis, Warren Benner, Huber Leath, Lee Brenner, Richard Slonneger, John Sullivan, Henry Long, Clara Brenner, Max Solomon, John Chubb, Marian Moedinger, James Harrison, William Moedinger, Isaac Hershey, Don Hallock, Winston Gottschalk, and Carol "Check" Caldwell. SRC's second caboose (C-2) is beside them.

The board of directors met after the annual shareholders meeting in March 1961. Pictured here are the members of the board. Seated on the left (from front to back) are Don Hallock, Henry Long, Winston Gottschalk, William Moedinger, and Isaac Hershey. Seated on the right (from front to back) are Max Solomon, Marian Moedinger, John Chubb, Richard Slonneger, Clara Brenner, Lee Brenner, Huber Leath, Carol "Check" Caldwell, and Jan Deelman.

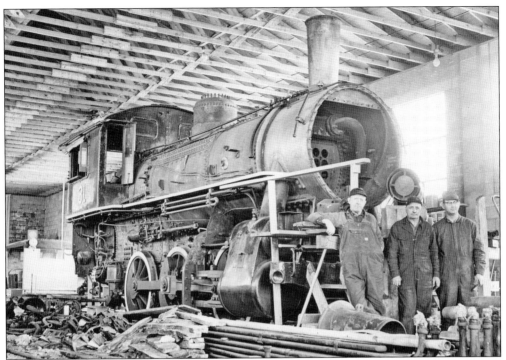

In this March 1, 1962, photograph by John Bowman, Reading Company boilermakers, Chester Eifert (left) and Robert Wildermuth (center), along with SRC's Huber Leath stand in front of ex-CNR No. 7312 during its retubing.

During the first few summers, Strasburg's flatcar—ex-PRR class GRa wooden gondola No. 335287, later renumbered as SRC No. 120—was equipped with longitudinal benches and served as the company's first open-air observation car. This c. 1960 photograph by Bud Swearer shows passengers trying to get a glimpse of an Amish buggy or a farmer working in his fields on their jaunt through the countryside. (Lynford Swearer Collection, Railroad Museum of Pennsylvania, PHMC.)

SRC vice presidents Don Hallock (left) and Max Solomon, both decked out in train attire reminiscent of 1915, discuss important train matters on one of their countless trips serving as the train crew of the historic Strasburg Rail Road.

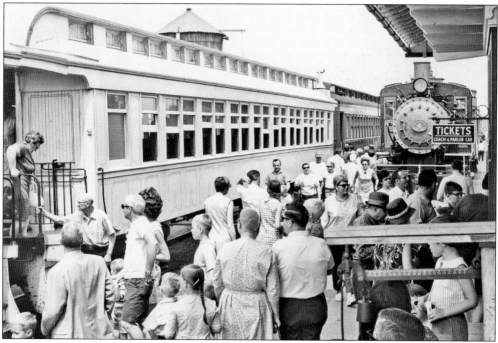

Strasburg Rail Road's unique camelback locomotive No. 4 sits on display just beyond the East Strasburg Station as passengers clamor for tickets and an opportunity to board the train. Note the yellow coach at left, which had been painted and pinstriped for the filming of *Hello, Dolly!* in 1968.

From left to right, John Bowman, Bob Wildermuth, Frank Herr, Huber Leath, Glen Lefever, George Martin, Dave Herr, Sam Zimmerman, Ellis Bachman, and Don Dorwart pose in front of No. 90 in this December 8, 1967, photograph by John Bowman.

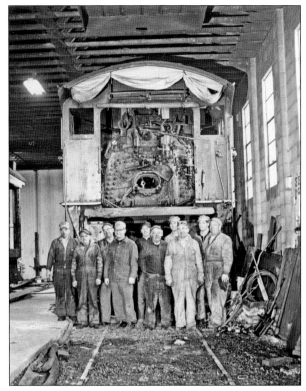

Before returning to Strasburg from Leaman Place Junction, (from left to right) Ellis Bachman, Don Hallock, Lee Brenner, Bill Fennel (as Santa Claus), Chester Slicer, Winston Gottschalk, and Ben Kline pose in front of the *Cherry Hill* coach on the "Santa Special" train in this 1962 photograph by Bud Swearer.

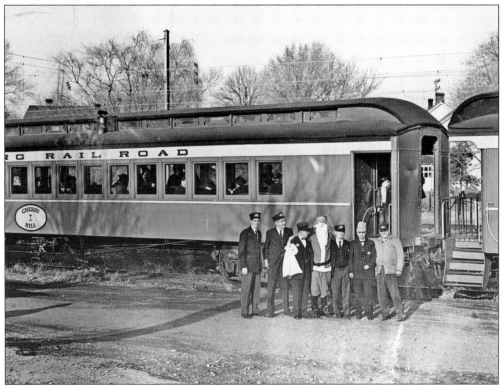

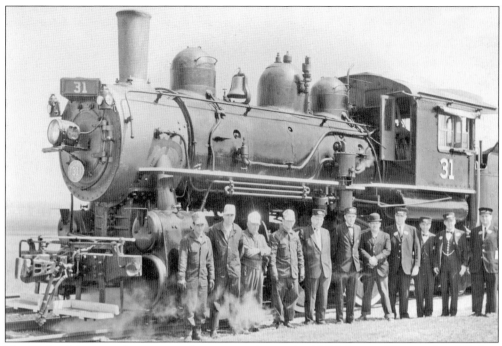

No. 31's big debut into the tourist industry came during the 1961 Memorial Day weekend. Before the engine pulled its first passenger train on Monday, May 29, 1961, Bud Swearer insisted that the crew pose for a photograph. Shown are, from left to right, John Bowman, Bud Swearer, Cal Shenk, Huber Leath, Jan Deelman, Donald Hallock, Ben Kline, Nelson Bowers, Winston Gottschalk, Lee Brenner, and Max Solomon.

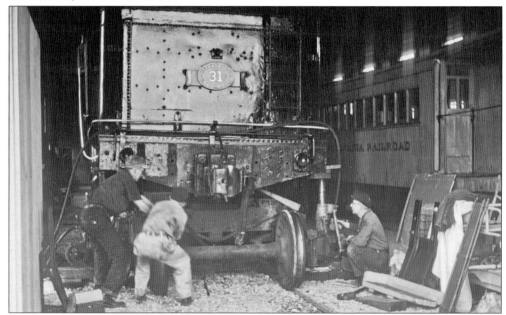

Three PRR employees help to reposition one of the trucks off of No. 31's tender. Notice the c. 1855 CVRR combine car sitting on the adjacent engine house track in this undated photograph by Huber Leath. (Huber Leath Collection, Railroad Museum of Pennsylvania, PHMC.)

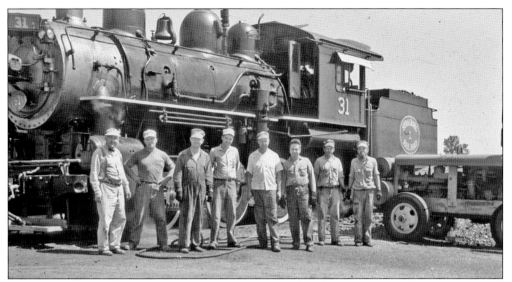

From left to right, two unidentified men, Huber Leath, Ellis Bachman, John Stuckey, Fred Hamerlehle, John Bowman, and Homer Long pose in front of SRC No. 31 in the early 1960s. The skilled machinists, mechanical engineers, and welders kept and continue to keep Strasburg's historic locomotives operable for the next generation. (Huber Leath Collection, Railroad Museum of Pennsylvania, PHMC.)

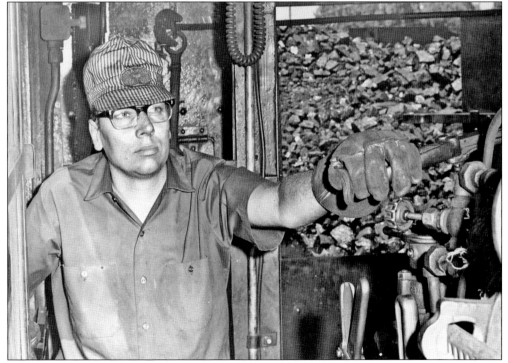

William Moedinger captured an image of Lynford "Bud" Swearer, a longtime SRC employee, sitting in No. 90's engineer's seat. Swearer was with the SRC from the very beginning. Thanks to him and his photography, much of the Strasburg Rail Road's rich history was recorded for posterity. (Courtesy of Linn Moedinger.)

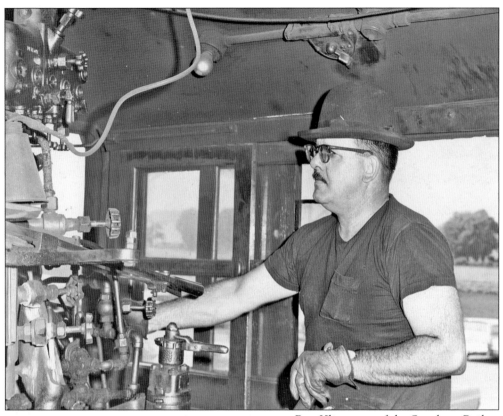

Ben Kline, one of the Strasburg Rail Road's first paid employees, is sitting in No. 90's cab in this photograph by William Moedinger. Kline also took a particular interest in the pre-1900 history of the Strasburg Rail Road. Much of what is known about the railroad in the 19th century was first unearthed by Kline. (Courtesy of Linn Moedinger.)

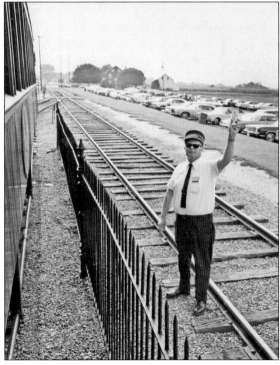

In this photograph by William Moedinger, Dave Canter gives the hand signal for safe locomotive movements on August 29, 1971. The wrought iron fence separating the two tracks was installed in 1964 for a "more authentic" look. The fence originally surrounded the Lancaster City Reservoir beginning in 1901.

In this classic photograph by Ellis Bachman, chief mechanical officer J. Huber Leath (left) gestures while discussing the day's operations with Jack Haines (center) and John Bowman in June 1982. Behind them is No. 31. (Ellis Bachman Collection, Railroad Museum of Pennsylvania, PHMC.)

Two long-time SRC employees—Linn Moedinger (left) and Stephen Weaver—stand in front of PRR No. 1223 on June 9, 1982, the 150th anniversary of the Strasburg Rail Road. Linn Moedinger is current president and chief mechanical officer, having served in that position since 2000. Stephen Weaver is the current vice president in charge of roadway, who oversees maintenance of way engineering and maintenance. (Courtesy of Linn Moedinger.)

Glen Lefever (left) and Rick Musser pose in front of "Gobblers Knob" in this November 1987 photograph. Lefever was a well-respected staple in the SRC car shop for nearly 45 years who almost singlehandedly kept the fleet of wooden cars in top quality shape. Rick Musser, who began his career at Strasburg in 1986, worked his way through the ranks and is currently vice president and assistant chief mechanical officer. (Courtesy of Richard L. Musser Jr.)

One of the most recognizable faces at the Strasburg Rail Road during the 1970s and 1980s was Earl "Red" Shaub, a 24-year veteran engineer at Strasburg. His retirement in 1992, after 30,000 trips run at the SRC, prompted local media attention. Here, Shaub poses in the cab of SRC No. 90.

The late Ellis R. Bachman, an SRC employee since the early 1960s, worked his way through the ranks and retired as vice president of administration. The Bachman family owns the Bachman Funeral Home, which has served the community since 1769 and is credited as America's oldest funeral home. Here Bachman displays some P&R memorabilia while standing in the East Strasburg Station.

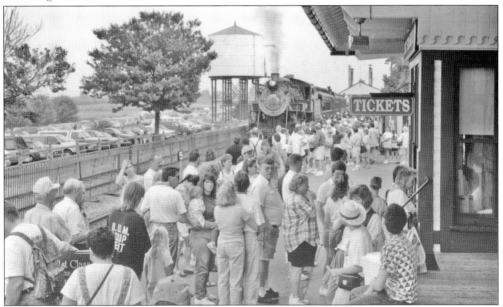

Throngs of visitors waiting on the platform is a typical scene at Strasburg. In this mid-1990s photograph, hundreds of on-lookers marvel at the historic ex-GW No. 90 steam locomotive as it pulls into the East Strasburg Station at America's oldest continuously operating railroad, tucked in the heart of Pennsylvania Dutch Country.

DISCOVER THOUSANDS OF LOCAL HISTORY BOOKS
FEATURING MILLIONS OF VINTAGE IMAGES

Arcadia Publishing, the leading local history publisher in the United States, is committed to making history accessible and meaningful through publishing books that celebrate and preserve the heritage of America's people and places.

Find more books like this at
www.arcadiapublishing.com

Search for your hometown history, your old stomping grounds, and even your favorite sports team.